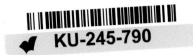

THE
WATERCOLOURIST'S
—GUIDE TO—
PAINTING BUILDINGS

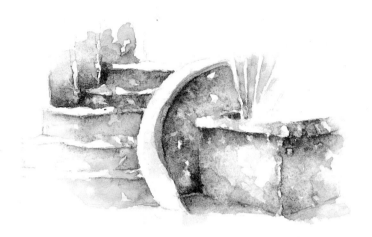

THE
WATERCOLOURIST'S
—GUIDE TO—
PAINTING BUILDINGS

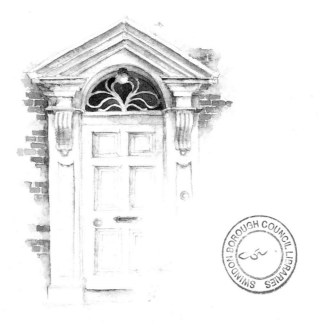

RICHARD TAYLOR

David and Charles

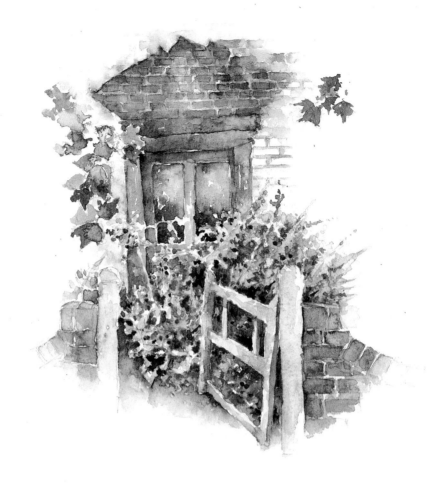

A DAVID & CHARLES BOOK

First published in the UK in 1998

Copyright © Richard Taylor 1998

Richard Taylor has asserted his right to be identified as author of
this work in accordance with the Copyright, Designs and Patents
Act, 1988.

A catalogue record for this book is available from the British Library.

ISBN 0 7153 0811 4

Book design by Casebourne Rose Design Associates
and printed in Singapore
by C.S. Graphics Pte Ltd.
for David & Charles
Brunel House Newton Abbot Devon

Contents

Introduction

BUILDINGS COME IN A WIDE VARIETY OF SHAPES AND FORMS, AND EXIST FOR MANY DIVERSE PURPOSES. FROM THE ARTIST'S PERSPECTIVE, THE FISHERMAN'S HUT ON THE FORESHORE IS OFTEN EQUALLY AS ATTRACTIVE AS THE COLONNADED MANSION — ALL HAVE THEIR PURPOSE, AND ALL HAVE VISUAL APPEAL.

This book is written from an artist's point of view – an artist with a love of structures, and a fascination for textures and how to recreate them in watercolour. I am not an architect, and have had no training in architecture – I simply respond as an artist might, to the environment within which I find myself and the visual stimulus that I seek is often to be found tucked away in the streets of villages, towns and cities.

The word 'buildings' embraces many types of structure, and I have attempted to choose as wide a selection as possible to illustrate a variety of watercolour painting techniques. I often try to seek out the unusual when on a painting or sketching trip – flaking plaster around an old street or shop sign, a rickety old barn door affording a view across the countryside through a few missing planks, or a decorative white column streaked with rust stains from an attached hinge or hook. Equally, I seek out the visually inspiring – the formal symmetry of classical façades, courtyards and cloisters with warm dappled summer shadows, and sail lofts along the foreshore. All these structures I find attractive, and all for different reasons that I shall elaborate upon in the following pages. I have devoted a chapter to one other aspect of painting in the built environment – street life. Even the smallest of towns, outback stations or hamlets only exist because of the people who have built them and who inhabit them. Without people, there simply would be no buildings, so I consider it essential to give thought to the best way of including them in paintings of the built environment.

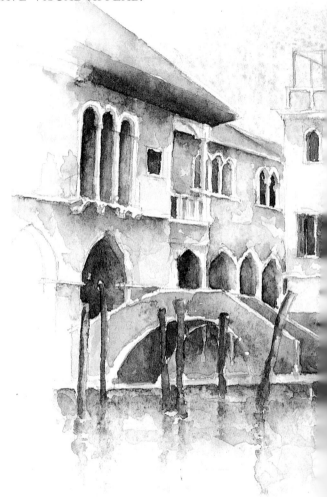

I choose to work in watercolour for several reasons, not least the accessibility and portability of the equipment required. My main reason, however, is the translucent quality of the paints. In brief, watercolour paints are tablets or tubes of pigment, bound with gum arabic, and given more body with a little filler. When they are made wet and applied to paper, the water evaporates, allowing the gum to dry, binding the

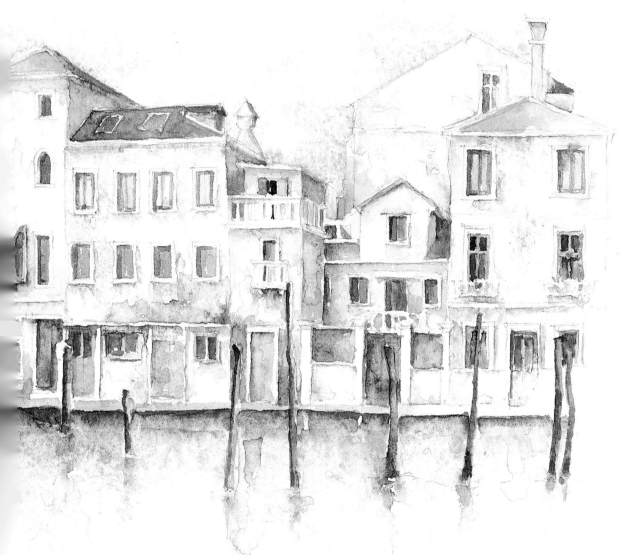

pigment to the paper. Every subsequent wash will allow the previous layer of gum-bound pigment to show through. These translucent qualities make watercolour an ideal medium for recording the fabric of buildings, where textures are always required and shadows are always in evidence.

On a final note, I have travelled widely and have never failed to find buildings and structures that hold some type of visual attraction or appeal wherever I have been. Again, I have attempted to include a wide variety not just of styles of building, but of buildings where the geographic location has determined the materials from which they were built. So, wherever you happen to find yourself, be it in your own high street or village, or in parts of the world that are foreign to you, keep your sketchbook handy at all times, and enjoy your painting.

CHAPTER ONE

EQUIPMENT AND TECHNIQUES

The wealth of buildings to be found, compounded by the variety of building materials available, means that it is extremely unlikely that any one painting technique will suit every scene – so it is best to experiment and discover the techniques that you wish to make your own.

This chapter deals with my own methods of working, which are, naturally enough, in part determined by the type of equipment that I choose to use.

I have two types of equipment: outdoor – the pocket-size set of paints that I can slip into my pocket and carry with me at all times, and a hardbacked ringbound sketchbook; and indoor – my studio equipment. The notes that you will make in sketchbooks are often of more value than a finished painting – they are more likely to be spontaneous responses to buildings and details that you see, and as such will probably be more personal to you than a highly developed picture made later in the studio.

I use few colours as I am a great believer in allowing your colours to work for themselves, mixing and bleeding freely on your paper as they are carried in the water medium. The more colours that you have from which to choose, the more likely it is that you will look for solutions in your paint box, trying to find the colour that matches most closely the one that you see. I prefer to allow a few colours to blend and bleed, discovering a subtle range of tones in the process.

A knowledge of the qualities of the main colours used for painting buildings is essential. By using a limited number of colours it is quite easy to become familiar with their qualities. I find it convenient to divide some (although not all) colours into warm and cold colours – this will help you to make some decisions when you are first starting to paint. In the short,

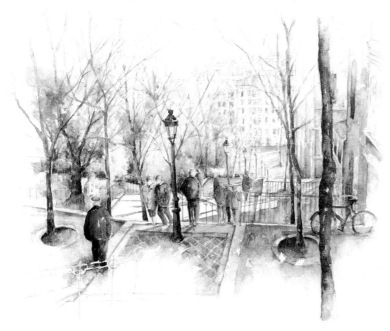

cold winter days, the shadows cast on and from buildings will require the choice of the colder blues and greens. Equally, the warm violets and oranges will be chosen to mix the shadows cast from the summer sun.

One technique that I enjoy using more than any other is that of dropping water onto wet or damp paper and observing the results. What happens in this process is that, when a drop of water falls onto wet or damp paper, it breaks the surface tension, forcing the paint outwards from the centre of the drip. This process both dilutes the paint, and creates a situation where it will dry to an uneven tone. While this may sound rather an undesirable feature, it is, in fact, absolutely necessary when painting surfaces such as brick walls, stone façades and rusty iron. This technique can often be enhanced by blotting out certain areas with a piece of kitchen paper.

For artists, an important aspect of painting buildings in watercolour is perspective, and the study of this could be expanded easily to fill several volumes of print. However, the central focus of this book is watercolour technique and I have tried to avoid an over-laboured look at the techniques involved in pencil sketching and building construction. A highly proficient pencil drawing will not always be improved by poor-quality painting; however, a skilled and knowledgeable application of watercolour paint can easily compensate for any technical inaccuracies of a quick line drawing.

Outdoor Equipment

SKETCHING BUILDINGS ON SITE IS BOTH A REWARDING AND A POTENTIALLY HAZARDOUS ACTIVITY. THE DEGREE OF SATISFACTION GENERATED BY CREATING THE LIKENESS OF A GATE OR MARKET STALL IS OFTEN COUNTERBALANCED BY A DELUGE OF RAIN, OR THE INCONVENIENCE OF HEAVING CROWDS BUMPING PAST YOU AS YOU SIT DOWN TO SKETCH OUT OF DOORS.

The equipment that most artists choose for working out of doors will have distinct qualities. It will be light, easily portable, and simple. My own equipment for painting and sketching out of doors is, indeed, simple. Firstly I use a small set of 'pan' paints. These can be bought in several sizes and qualities (some of the most expensive ones even have water containers attached), but the quality of the paints is the most important consideration. Pan paints come in two sizes – full pan and half pan (as illustrated here); and in two qualities – student quality and artist's quality. While the student-quality paints are fine when you are buying your first sets of paints, it will not be long before you will want to graduate to the artist's quality as they contain the purest pigment and result in the cleanest colours. Most tins come with a pre-chosen selection of paints, all of which are replaceable and, of course, you can then select your own colours.

My tin contains a retractable brush, which is the only one that I carry as it fits neatly into the set, next to a small pencil.

The most important part of my outdoor sketching equipment, however, is a hardbacked ringbound sketchbook. This is small and light enough to be carried in a back-pack, and the hardback binding prevents it from becoming creased or folded. The strength of the hardback also means that you will always have something to lean on when working 'on site', eliminating the need to carry cumbersome drawing boards.

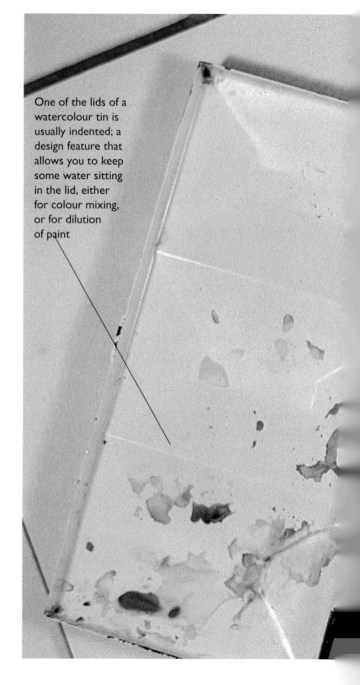

One of the lids of a watercolour tin is usually indented; a design feature that allows you to keep some water sitting in the lid, either for colour mixing, or for dilution of paint

This photograph illustrates the equipment that I use when sketching 'on site'. The paints and the brush are contained within the watercolour tin, which folds up and fits into a pocket. As well as a sketchbook and pencil, I also carry a screw-top jar for water

A hardback, ringbound sketchbook is invaluable when working out of doors. It gives a solid surface on which to work and allows you to keep all your work safely together

I usually take only one brush on sketching expeditions: the retractable brush supplied with the watercolour tin

A B-grade pencil is good for sketching

Pan paints (and tubes) can be purchased individually to suit your own choice of colours

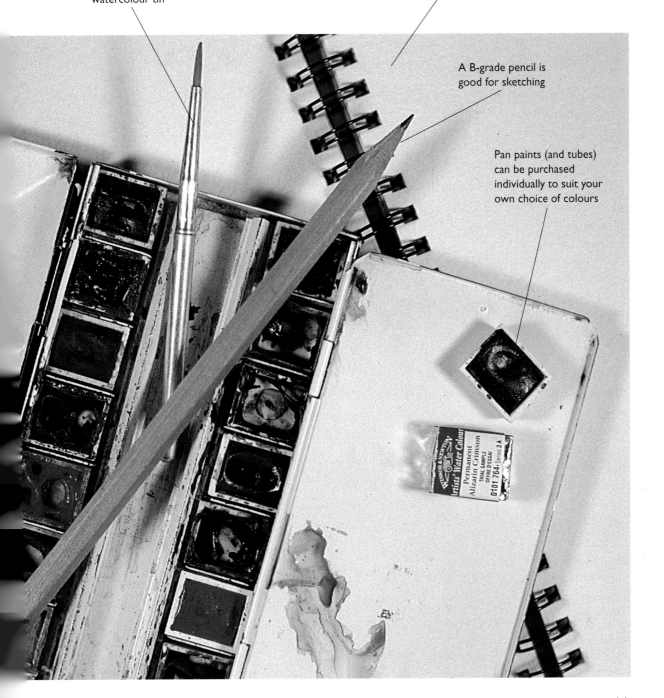

Indoor Equipment

I N THE PRIVACY OF YOUR OWN HOME, YOU CAN AFFORD TO EXPERIMENT A LITTLE MORE WITH YOUR EQUIPMENT AND TAKE SOME CHANCES THAT YOU MIGHT NOT ATTEMPT IF YOU WERE ON PUBLIC DISPLAY.

My indoor, or studio, equipment is only a little more elaborate than my sketching equipment: I just use a few more of everything, but the principle of simplicity is still the same.

I like to use tube paints when working indoors. The only real advantage that these paints have over pan paints is that you can pick up a lot more paint on your brush as you squeeze them from the tube, allowing you to achieve more intense colours a little more quickly. I squeeze these paints out into compartments in a large white plastic mixing palette with lots of space for mixing colours with water.

I also use three brushes – large (No.14), medium (No.6) and small (No.1). Sable brushes are good, but the better-quality synthetic brushes run a very close second these days.

I tend to paint onto sheets (rather than pads) of watercolour paper as these give me the freedom to choose the size and scale to which I am going to work. My personal choice is for NOT, or Cold Pressed (CP), paper, which is a slightly textured, general-purpose paper that comes in a variety of weights – the lightest being around 90lb (190gsm, or g/m²), with the heavier papers

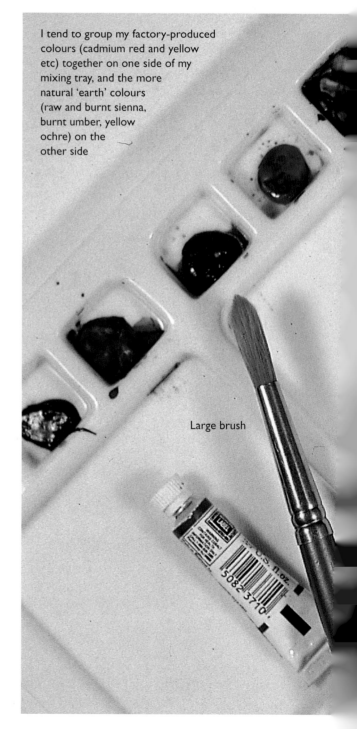

I tend to group my factory-produced colours (cadmium red and yellow etc) together on one side of my mixing tray, and the more natural 'earth' colours (raw and burnt sienna, burnt umber, yellow ochre) on the other side

Large brush

My personal choice of colours:

(most used)
Raw sienna
Burnt sienna
Burnt umber
Cobalt blue

Ultramarine
Sap green
Cadmium yellow
Cadmium red

(less frequently used)
Yellow ochre
Terre verte

This photograph illustrates the equipment that I use in my studio. Although these items are easily transported, they do not fit quite so easily into a pocket as the equipment on pages 10–11

around 300lb (638gsm). I use a medium-weight paper around the 200lb (400gsm) grade as this rarely needs stretching and will stand up to some quite rough treatment.

My only additional equipment is a roll of textured kitchen paper. This is invaluable for 'scrunching up' and blotting out unwanted watercolour bleeds.

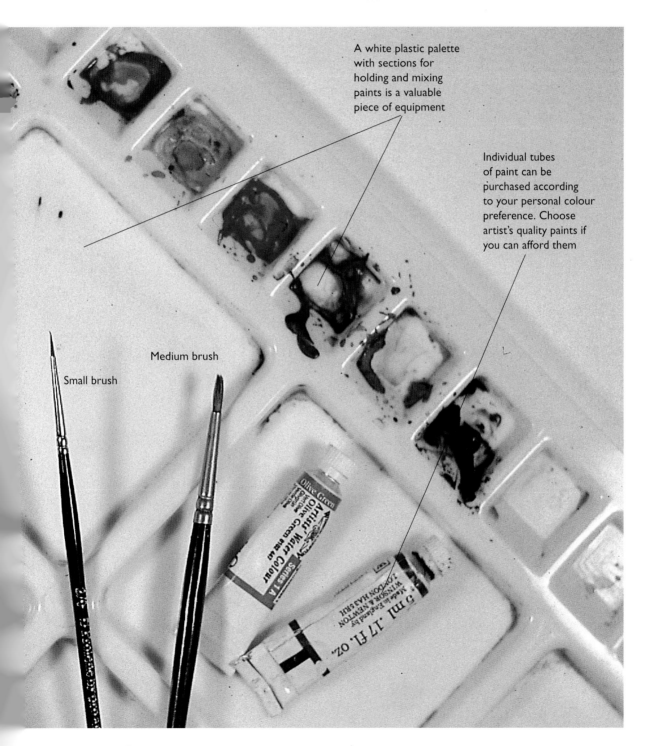

A white plastic palette with sections for holding and mixing paints is a valuable piece of equipment

Individual tubes of paint can be purchased according to your personal colour preference. Choose artist's quality paints if you can afford them

Medium brush

Small brush

Colour Values

As artists, we often have to balance what we feel and what we see. The chill of a spring morning may tell our hands and feet that it is not hot; our choices of colours may need more thought.

Using colours from the cool end of the spectrum (here, cobalt blue, yellow ochre and terre verte), cold colours are usually achieved by mixing thin paint – a mix with little paint and a lot of water

Cobalt blue was used for the sky

The tree colours were created by mixing cobalt blue and burnt umber and painting directly onto the paper, leaving the coldness of the white surface to show through the translucent paint

Shadows were created by mixing cobalt blue with burnt umber

Cool green, mixed with sap green, cobalt blue and terre verte

Cobalt blue

Cold colours

Yellow ochre

Terre verte

WINTER SHADOWS

Buildings themselves do not really hold any temperature on the outside. The light and atmosphere of the day, however, do – and it is these elements, and the way that they affect the appearance of the buildings, that we want to record.

To paint a building on a cold winter's day will necessitate the use of a different set of colours from those that you would choose to use in the middle of a warm summer.

14

SUMMER SHADOWS

To add a feeling of warmth to this scene, the sky was painted using a mixture of ultramarine and ultramarine violet

Most colours can be associated with a colour 'temperature', meaning that they will appear to give a warm or a cold feel to a picture, especially when used in conjunction with other colours of a similar value – and here lies the key! Cold colours used together

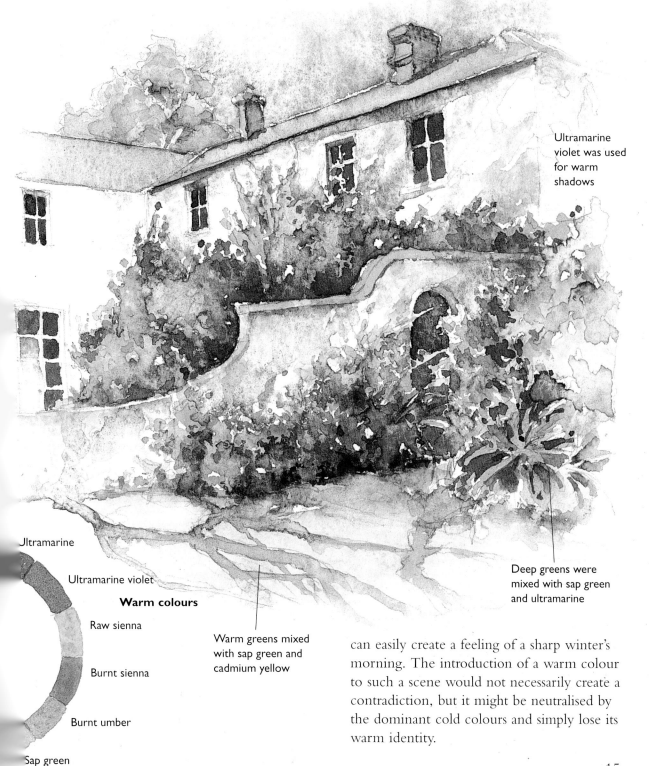

Ultramarine violet was used for warm shadows

Deep greens were mixed with sap green and ultramarine

Ultramarine

Ultramarine violet

Warm colours

Raw sienna

Warm greens mixed with sap green and cadmium yellow

Burnt sienna

Burnt umber

Sap green

can easily create a feeling of a sharp winter's morning. The introduction of a warm colour to such a scene would not necessarily create a contradiction, but it might be neutralised by the dominant cold colours and simply lose its warm identity.

Sketchbook Studies

A SKETCHBOOK IS AN ARTIST'S MOST VALUABLE TOOL. THEY COME IN MANY SIZES, CAN BE CARRIED EASILY, AND CAN BE USED TO MAKE VISUAL NOTES WHEN TIME, OR PERSONAL INCLINATION, DOES NOT ALLOW FOR ANY MORE PAINTING.

I cannot overemphasize the value and importance of sketchbook studies. They allow you to make as many visual notes as you wish, to gain information about the nature of the building you are painting, to find out about the qualities of the paint and paper that you are using, and the best techniques to use for your particular subject.

My principles for sketching are straightforward – the gathering of information, and the exploration of the qualities of the fabric of the particular building or buildings that I have chosen for my subject.

In the on-site sketch of an old town house on the opposite page, I have made a general sketch together with some studies of details. A sketch does not have to be the same as a finished picture. For instance, it is not necessary to draw or paint in all the windows. An enlarged study of the way in which the wooden window frame sits in the recess may be of more value. Equally, a study of the brickwork on one of the columns may be of more value than recording all the decorative brickwork.

As I said on page 10, I use very simple equipment for sketching. This makes it easy to sketch a scene from a car window.

Because I usually use only one brush when I am sketching, most of my brushstrokes will be of a similar size and nature. I therefore tend to use the technique of dropping water onto damp paint and allowing it to flow freely, carrying the paint with it, to create areas of surfaces such as walls or tiled roofs – especially where textures are involved – and I use the tip of the brush only for creating specific details on shadows.

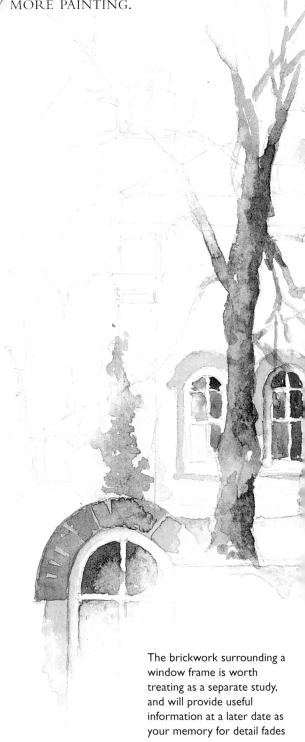

The brickwork surrounding a window frame is worth treating as a separate study, and will provide useful information at a later date as your memory for detail fades

TOWN HOUSE SKETCHBOOK STUDY

Burnt sienna and
burnt umber

Burnt sienna

Depth of tone is created with
burnt sienna and burnt umber
with the addition of ultramarine

Studies of the tonal aspect
of architectural details in a
sketch will help to prevent a
building from looking flat

It is important to note the
directions of shadows

Features such as windows
often have a variety of
designs in the more
attractive buildings

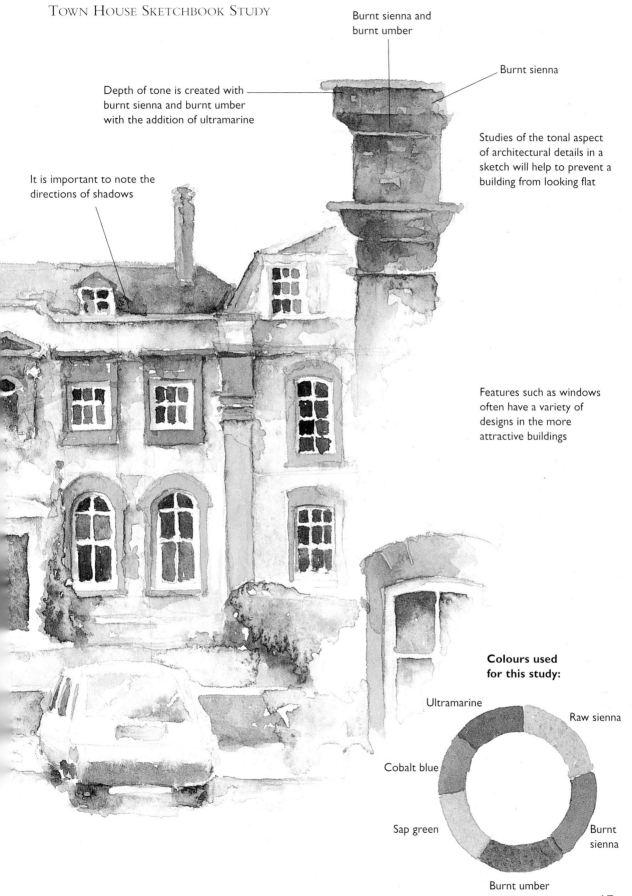

**Colours used
for this study:**

Ultramarine

Raw sienna

Cobalt blue

Sap green

Burnt
sienna

Burnt umber

17

Working Methods and Techniques

THIS DEMONSTRATION, IN STEP-BY-STEP STAGES, SHOWS HOW I DEVELOPED THE ON-SITE SKETCH OF THE OLD TOWN HOUSE (ON THE PREVIOUS PAGES) INTO A FINISHED STUDIO PICTURE. THIS IS TYPICAL OF MY WORKING METHOD, AND COVERS MOST OF THE BASIC TECHNIQUES THAT I USED FOR THE PAINTINGS IN THE BOOK.

The first stage is to transfer the on-site sketch to a more substantial sheet of paper in the more stable environment of the studio or on the kitchen table. Having decided to use all of the information gathered in the sketch, I will usually set about organising my paints next, ensuring that I have available and ready to use all the tube paints that I am likely to require to complete the painting.

The first stage is to apply an underwash (also known as an undercoat, base colour or base coat). This establishes the overall mood and colour temperature of the painting. No attempt is made at this stage to define light or shade. Since this is the first colour applied to the paper, it will influence the quality of every subsequent colour added over the top of it because of the translucent nature of watercolour.

The sky was painted with a large brush, using a mixture of cobalt blue and ultramarine, creating a fairly neutral blue. The brickwork and tiles were treated to a raw sienna underwash (with a medium-size brush) to create a 'warm' base for the next set of colours.

The next stage was to establish an underwash for the cooler tones of the plaster walls of the building, and the foreground and background. Using a lot of water, I mixed a combination of cobalt blue with a touch of burnt umber and painted this onto the dry paper with a medium brush, applying the paint to those areas of wall as yet unpainted.

1 The underwash was painted using a large brush for the sky, and a medium brush for brickwork. Wet paint was applied loosely and freely to dry paper.

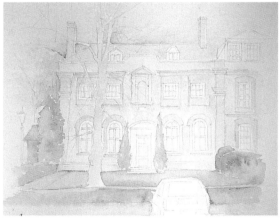

2 The underwash was painted onto the rest of the wall using a medium brush and cool tones mixed with cobalt blue and a touch of burnt umber. Foliage was treated in the same manner.

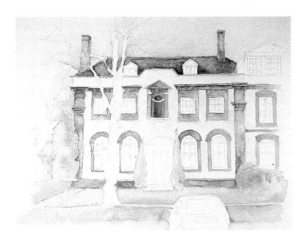

3 Brickwork was painted using a medium brush. Burnt sienna was painted on top of raw sienna to create the ideal brick colour. Roof tiles were painted onto the underwash using burnt sienna, cobalt blue and burnt umber.

No attempt was made to control the particularly watery paint at this stage. It was allowed to dry unevenly, representing random shadows and textures.

The underwash for the trees, bushes and grass was mixed using sap green, a touch of terre verte and cobalt blue. Again, an extremely watery mixture was used and painted in very freely, with no attention to detail, using a medium-size brush.

Having created the underwash over most areas, the next stage was to begin to develop the colours of the main areas of the building.

Referring to my sketchbook studies, I started work on one of the most dominant features: the decorative brickwork. The rich, red-brick colour of burnt sienna is ideal for this type of feature. Using a medium-size brush, I painted the burnt sienna onto the dry underwash of raw sienna. Owing to the translucent qualities of watercolour paints, the effect of this action was that the warm raw sienna underwash blended visually with the burnt sienna brick colour, creating an acceptable set of brick tones. Using the same technique – wet paint washed across a dry underwash – the roof was painted, using a mix of burnt sienna, burnt umber and a touch of cobalt blue to create the old tiles.

When the roof and bricks were complete, the next area to be developed was the bulk of the walls. Having established a cool underwash to represent the years of exposure to cold and damp weather, some 'body' had

to be added. I chose to use raw sienna again as this would have the effect of partially neutralizing the cool tones as it covered the underwash, leaving them exposed where the paint did not cover the paper evenly. Using a medium brush, I began to employ a technique that I use frequently in my painting where I wish to avoid smoothness in a stone or plaster wall. Using the tip of the brush, I painted a wash of raw sienna very loosely and freely across the walls, working around the windows and door. Then before this application of paint had time to dry, I allowed a few drops of clear water to drip onto the damp paint, diluting some areas but not others, and I allowed the paint to run, bleed and dry to the desired uneven finish.

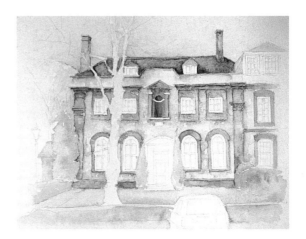

4 Textures and tones on the walls were created by applying raw sienna freely with a medium brush, and selectively dropping clear water onto damp paint to create an uneven finish when dry.

19

5 Windows were painted with a small brush – each pane being painted with a mixture of ultramarine, cobalt blue and a touch of burnt umber. Some panes had clear water dropped onto them to dilute the paint.

With most of the building's fabric complete, the next areas to develop were the windows, all of which were painted using a small brush.

Windows can be tricky to paint, not so much because of their shapes, but more for the colours used. The technique I generally use to paint windows is to create a watery mixture of ultramarine, cobalt blue, and a touch of burnt umber to add depth to the tone and remove the potentially artificial blueness. I will then apply this paint, as in this example, to a selection of window panes within the one frame, and allow these to dry. The one or two remaining panes will have some paint applied in one corner, and a little clear water will be dropped onto the paint, diluting and dispersing it. This will dry lighter and uneven in tone, creating the appearance of reflections.

The final stage of this painting was to enhance the background trees and to develop the tones and detail in the foreground. For this I returned to a medium brush and mixed some sap green with a little cobalt blue and a touch of burnt umber for depth. I applied this mixture to the shaded side of the bushes and, as it dried I dropped some water onto the edges to encourage bleeding. The tree in the immediate foreground was painted using the same technique, with burnt umber and cobalt blue as the key colours. Finally the car was included, with a shadow area underneath it that was strong enough to support it visually - that is, to ensure that it really looked as if it *was* casting a strong shadow, one which connected with the wheels and so prevented the car from appearing to hover above the ground.

6 Dark tones on the bushes and trees were added by painting a dark mixture of sap green, cobalt blue and burnt umber onto the shaded side. Water was dropped into this to encourage the paint to run and dilute.

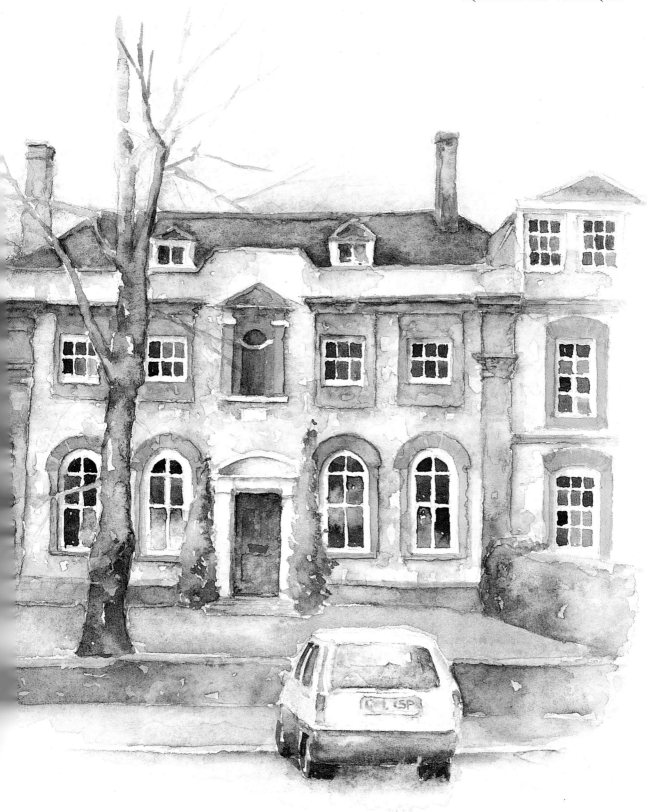

TOWN HOUSE – FINISHED STUDIO PAINTING

Although you may not use all the information in your sketchbook study in your final studio painting, you should keep the sketch – you never know when the information may be of use

Construction and Perspective

DEVELOPED BY THE ARTISTS OF THE ITALIAN RENAISSANCE IN THE FIFTEENTH CENTURY, PERSPECTIVE WAS CREATED TO ENABLE ARTISTS TO INTRODUCE SCALE AND ORDER INTO THEIR PICTURES. BUT DO NOT BE TEMPTED TO BECOME A SLAVE TO ITS TECHNICAL RULES, EVEN FOR A SUBJECT AS DEMANDING AS BUILDINGS. SPONTANEITY AND FRESHNESS ARE, I BELIEVE, OF MORE VALUE TO THE WATERCOLOUR ARTIST.

While I always promote developing an 'eye' for the lines of buildings through sketching, rather than laboriously and technically constructing perspective, it is important to understand the principles that underpin our ways of translating three dimensions onto a flat sheet of paper.

Perspective is a method of creating a sense of visual order from the complexity of the world we see around us. It is based upon a system of converging lines. In the main illustration on the opposite page, I have left all the perspective lines showing. If those converging lines were to be continued to the left, they would eventually meet at a single point on a line that corresponds with your eye level and the horizon (see the small annotated illustration). The reality is, however, that you will hardly ever see a horizon line, except at sea or in vast open countryside (where few buildings are to be found). It is best, therefore, to practise sketching with the knowledge that all the lines that you draw on either side of your buildings will appear to converge. It is also important to ensure that all vertical lines are drawn parallel and upright to prevent your buildings from looking as if they are leaning.

Most buildings can be constructed on a 'box' system, involving little more than basing your drawing on a three-dimensional box and adding assorted features such as a roof, chimneys or extensions. The pencil illustrations opposite show how a simple building shape can be constructed. You will usually only be able to see two sides of any one building at any time, although of course you will see various sides of other buildings.

You may find this box construction system useful, particularly with domestic buildings, and with simple sheds and huts, which are the best type of buildings with which to start when you first begin to paint.

Perspective enables us to translate the three-dimensional world onto a flat sheet of paper

Perspective lines on the same plane will appear to converge to one single point on an invisible horizon

One handy rule to remember is that lines of windows and other features that are above your head will converge downwards, while those below your line of vision will converge upwards

This diagram illustrates the points to which the perspective lines will converge in this picture

BUILDING PERSPECTIVE

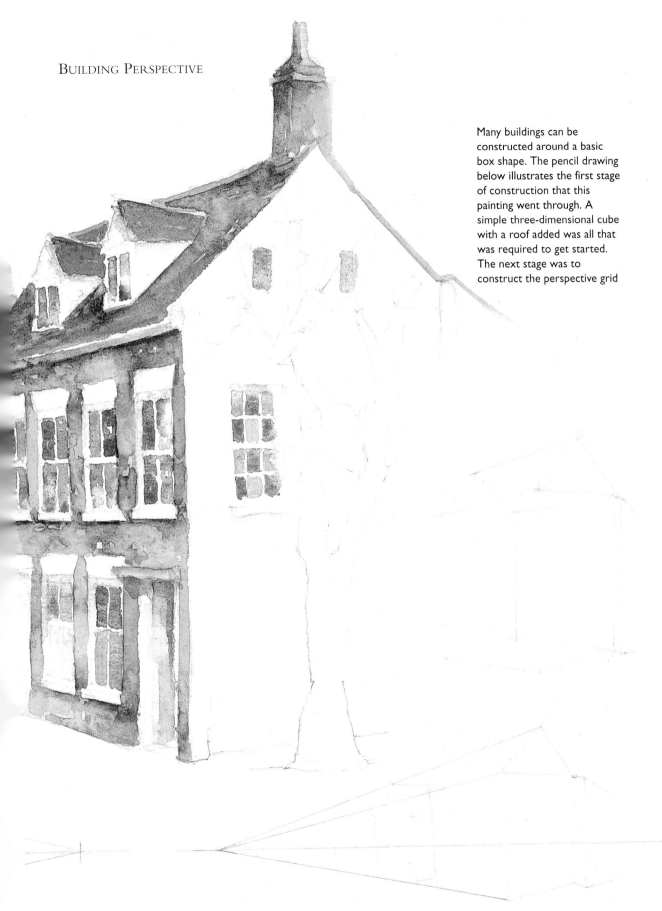

Many buildings can be constructed around a basic box shape. The pencil drawing below illustrates the first stage of construction that this painting went through. A simple three-dimensional cube with a roof added was all that was required to get started. The next stage was to construct the perspective grid

SHEDS, SHACKS AND OUTBUILDINGS

It is common practice for property developers and town planners to neglect or tear down the old, only preserving the quaint parts of old towns and cities. But as artists we can find visual clutter, decaying brickwork, rotting timbers and rusting iron a pleasure to record.

The sheds, shacks and outbuildings in this chapter include those often very interesting types of building that are generally used for work or some industrial purpose, and that are often to be found in a state of some disrepair (although this need not necessarily be the case). They are often made of wood (or at least have a fair amount of timber exposed) and might make use of cheap sheet metal for roofs or extensions. I have selected examples of waterfront buildings and sail lofts as well as rundown and ramshackle shacks in which people once lived. The list is extensive: barns and haylofts, railway sheds, timber huts and lakeside boathouses, as well as backwoods cabins and outback shelters. All of these types of building have their own individual charm and appeal.

The subjects in this chapter are a good starting point if you are new to painting buildings, as they are usually fairly simple in construction, and so the drawing stage of the work does not present too much complication in terms of perspective.

But what exactly is the visual appeal of a rusting old shed with a door hanging on its hinges, or the bare skeleton of an old barn with only a few planks hanging limply by a rail? To artists, the appeal may be the random nature of the shapes (for instance, the irregularity of a stone shelter exposed to the elements, with one of its walls collapsed and a pile of old bricks scattered around its base), or it may be the textures that the effects of nature and the elements on man-made materials can create (rust stains that have run from old iron hinges, creating a wealth of red and brown

tones on a faded, white wooden door). It may be simply the visual clutter found on or around such buildings.

The colours and textures of these buildings provide ideal opportunities to investigate various watercolour techniques. Runs, bleeds, patches and stains are all easily achievable using simply a good strong sheet of watercolour paper, a brush that will hold a lot of water and a few sheets of kitchen paper for blotting out paint to create textures. Textures can be created with a drop of water onto damp paint, and stains by simply allowing some paint to run across your paper, finding its own course.

While these buildings can have a tremendous attraction for artists, many only have a particular section that we wish to record. Or they might be more appealing as sketchbook studies rather than as a finished picture.

Sketchbook studies are of great value to the watercolour artist as they provide a good source of practice. They also serve as useful references that you can turn to at any time to see just how and where you recorded that particular shed with its irregular windows and stained weatherboarding, or the colours that you mixed to record the ivy and creepers that curled themselves around the old wooden gate that grabbed your attention as you strolled around the old part of town that you visited on your summer holiday last year.

All these stimuli, inspirations and memories can be recorded in a sketchbook, on a small scale and with minimal equipment.

Boatyard

SOMETIMES THE STRONGEST VISUAL APPEAL OF A BUILDING IS CREATED BY THE EFFECTS OF AGEING. WHILE DEVELOPERS AND ARCHITECTS MAY WISH TO DEMOLISH CRUMBLING OR RUINED STRUCTURES, OR TO REDESIGN THEM, WE AS ARTISTS WISH SIMPLY TO PAINT THEM.

This small section of an old boat-building yard was chosen mainly for its combinations of textures – old, faded wood, stained by years of weathering, and the rust colours of the corrugated iron. These were enhanced by the reflections on the damp foreground.

The key to painting this scene was to combine several different techniques. Firstly, a large brush was used to wash on very watery undercoats of raw sienna and burnt sienna, allowing them to bleed together as they ran and flowed. This was applied very freely with no concern for details at this point, except to make sure that the windows and the pure white of the boats and masts were left untouched. Secondly, as the undercoat was drying, certain areas were blotted with a piece of kitchen paper – a technique that helps to create a patchy appearance. The buildings now had all the correct colours and tones, and were looking patchy and textured.

Thirdly, when the painted areas had dried thoroughly, a small brush was used to paint details, working with more care than had been necessary with the two previous techniques. Shadows on the large wooden shed were picked out to enhance the effects created by the blotting technique, and to give the appearance of the surface of the wooden wall (see page 29). Smaller yet equally important areas, such as ladders leaning against walls, were also painted. These were created by dropping a very dark mixture of burnt umber and ultramarine in between the rungs. The depth of these tones appears to push the underwash forward, creating a three-dimensional appearance.

The weathering of old wooden sheds can be an attractive visual feature. It is best recorded by using lots of water and pulling the paint downwards in vertical strokes, allowing it to bleed freely

As you will often be working with a limited range of colours when painting old sheds and outbuildings, you will need to concentrate much more on the subtle tones that you can achieve

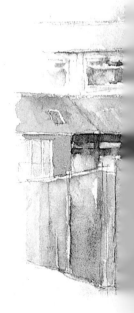

The warm grey concrete tones have been created by mixing all four colours together (see page 27), and pulling them downwards onto damp paper. Before these had time to dry, some burnt sienna was dropped on to reinforce the feeling of warmth

Only four colours were used
to paint this picture: raw
sienna, burnt sienna, burnt
umber and cobalt blue

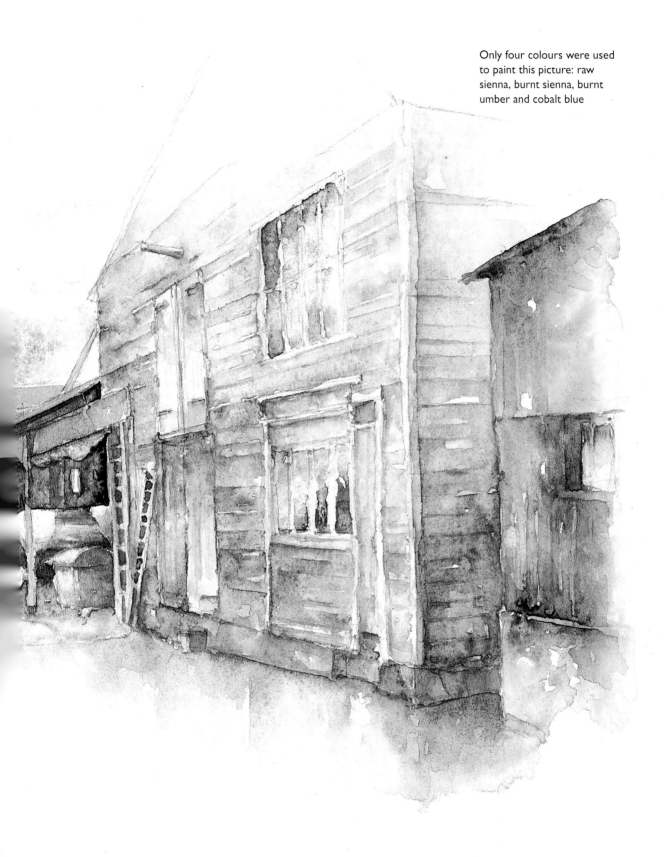

27

Seaside Buildings

SINCE THE DAYS WHEN MEN FIRST WENT TO SEA IN BOATS TO FISH, BUILDINGS HAVE BEEN CONSTRUCTED ALONG THE SHORELINE. BUILT ORIGINALLY TO HOUSE BOATS AND TO PROTECT THE FISHERMEN'S FAMILIES FROM THE ELEMENTS, THEY SUBSEQUENTLY DEVELOPED INTO FULL-SCALE COMMUNITIES.

The visual clutter of colours and signs that frequently occurs on seafront buildings can be a delight for the artist to record in watercolour

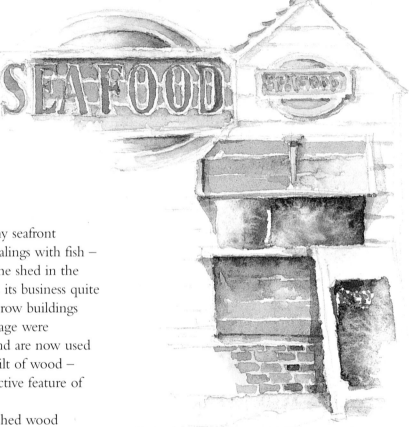

The combinations of faded and exposed wood, whitewashed weatherboarding and old brick are a large part of the appeal of seaside buildings

A common function of many seafront buildings is connected to dealings with fish – either catching or selling. The shed in the study on this page proclaims its business quite obviously, while the tall, narrow buildings illustrated on the opposite page were originally used as sail lofts and are now used for drying nets. Both are built of wood – another common and distinctive feature of many seaside buildings.

For the artist, a whitewashed wood building creates a strong backdrop for signs and architectural details to stand out against, as can be seen in the study on this page.

The large red and green sign advertising seafood adds a strong decorative element to this wood- and brick-built shop front. The slightly faded appearance of the sign, battered by gales during the winter and exposed to the salt carried on the sea breezes during the summer, was achieved by using more than the usual amount of water.

Also of interest to the artist is the construction of wooden buildings, which involves overlapping each plank of wood on top of the plank underneath. This allows water to run freely down the walls without being allowed to collect and start to rot the wood. The best way to depict this method of construction in watercolour (for natural and painted wood) is by running a line of light blue paint – cobalt or ultramarine – directly underneath a plank and pulling the paint downwards, graduating the shading in the process. In situations where you are confronted with large areas of wood planks

My choice of colours, or palette, for painting natural wooden buildings

Burnt umber

Cobalt blue

Raw sienna

Ultramarine

Burnt sienna

Broken brushstrokes will expose the paper underneath, giving wood a patchy look

Weather-beaten wood can be painted using a minimal amount of colour. It is the variety of tones and the quantity of water used that matters

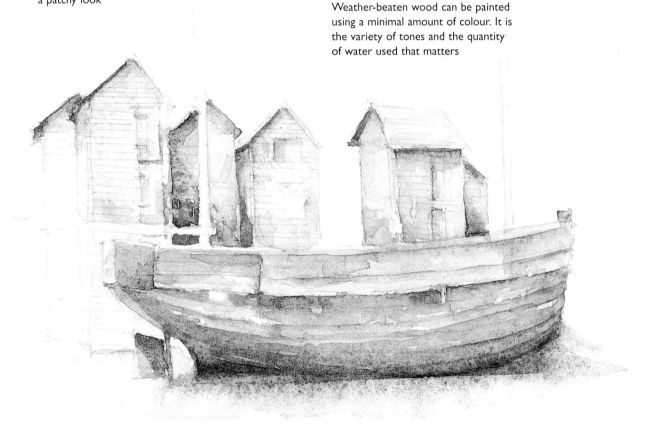

(usually referred to as weatherboarding), it is best not to try to shade each plank, but to employ the technique of suggestion, and to select only a few to record.

Interestingly, yet predictably, the method of construction of the buildings and the boat are the same – overlapping planks fashioned to a specific shape to prevent water penetrating. Here lies the value of making sketches and studies prior to embarking on a major painting. Knowledge of your subjects can only help your work.

The colour of natural weather-beaten wood is best recorded with a series of washes, using natural colours such as raw sienna, burnt sienna and burnt umber, and allowing these to mix freely on the wet paper. Blotting with a sheet of kitchen paper will help to create the sunbleached feel of wood that has stood against the seaside elements for years. If the washes are kept very pale, the underlying drawing can be allowed to stand as an integral part of the finished painting.

Sail Lofts

THE COMBINATION OF BRICK AND WOOD CAN BE VERY APPEALING VISUALLY. THE WARMTH OF THE EARTHY SIENNAS AND UMBERS IN THE BRICKWORK PROVIDES A GOOD FOIL FOR THE STARKNESS OF THE WOOD, PARTICULARLY IF IT HAS BEEN PAINTED OR WHITEWASHED.

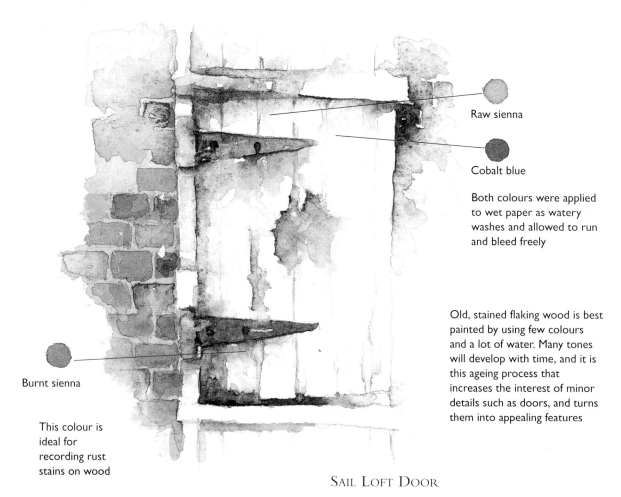

Raw sienna

Cobalt blue

Both colours were applied to wet paper as watery washes and allowed to run and bleed freely

Old, stained flaking wood is best painted by using few colours and a lot of water. Many tones will develop with time, and it is this ageing process that increases the interest of minor details such as doors, and turns them into appealing features

Burnt sienna

This colour is ideal for recording rust stains on wood

SAIL LOFT DOOR

This sail loft door offered many of the attractions so typical of old seafront buildings – the irregularity of the structure itself, the faded and chipped paint exposing the natural wood underneath, and the rust bleeds from the metal hinges running down the yellowing whitewash. A perfect subject for a sketchbook study.

The faded appearance was created by dampening the paper and dropping on some very pale, watery washes of cobalt blue and raw sienna. These paints flowed gently across the damp paper, drying to an irregular, patchy appearance (which can be enhanced by blotting out with a piece of kitchen paper). The rust stains were created using a similar technique, but working directly onto dry paper. Burnt sienna was a natural colour choice; its warmth and translucency is perfect for rust stains. A watery mixture was applied directly under the bottom of the hinge and a few droplets of water were encouraged to fall onto this, creating a watery, soft bleed which, when pulled downwards, gave the right effect.

PROJECT: SEAFOOD SHEDS

First I completed a pencil drawing that outlined the main structures. The next stage was to establish the base colours that were to serve as the undercoat.

The undercoat, or underwash, is always crucial in establishing the overall colour temperature of a painting, and although the lighting was fairly strong when I made my sketches, I was determined that the overall scene would maintain a cool feel. I used a mixture of cobalt blue and ultramarine to create the sky. The brickwork was underwashed with a watery mix of raw sienna and burnt sienna, and the exposed wood was painted with another watery mix but this time using the sky colour mixed with a little burnt umber.

Once the underwash had dried, the next stage was to introduce an element of form

into the scene, and this was achieved through light and shade. The strong angular shadows cast by the buildings held the key to this, especially the way in which they fell on walls and across roofs. When the underwash was totally dry, a mixture of cobalt blue and ultramarine (the same as the sky mixture) was washed across the areas of the buildings on which the shadows were falling. Other colours would be painted onto these shaded areas, but as with the underwash, the translucency of the watercolour medium dictates that the coolness of the shadow blue will always show through, exerting an element of control over those paints which will subsequently be applied.

As soon as the shadow wash had dried, the immediate background became the centre of focus. The tall brick building with

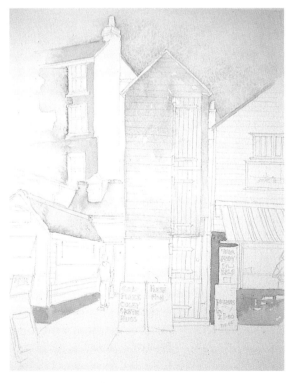 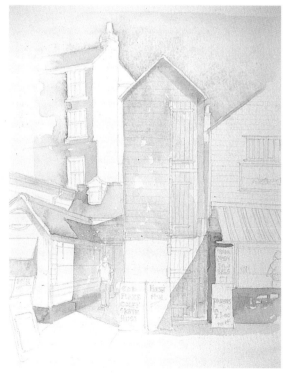

1 Cobalt blue and ultramarine were used as a base for the sky, applied with a medium brush onto dry paper. An underwash of raw and burnt sienna was used for the bricks and tiles.

2 The sky base wash was used for the shadows on the buildings, again using a medium brush on dry paper.

31

3 The sky mixture was added to burnt umber to create a dark brick colour. For the tiles, raw sienna was mixed with a touch of burnt umber and applied with a small brush using broken horizontal strokes.

4 Signs and boards were also painted with a small brush. Burnt umber and ultramarine were mixed to create the colour for the blackboards.

its strikingly strong whitewashed side wall was the first section to be painted. The windows were painted using the sky mixture and a touch of burnt sienna, while the brickwork was painted using burnt sienna with a touch of the sky mixture. The paint was not applied evenly, allowing some of the raw and burnt sienna undercoat to show through, suggesting the texture. The terracotta tiled roof was painted in a similar manner. A mixture of burnt sienna enhanced with a touch of burnt umber was pulled in horizontal strokes across the roof, allowing the undercoat to show through in parts, and to imply the effect of light catching the ridges on the tiled roof.

The final features of this composition were the weatherboarding on the sail loft and sheds, and the clutter of signs and boards advertising fish for sale. The technique for painting overlapping wooden planks has been described on page 28. Here the sky colours were used for the shadows underneath the planks.

The blackboards outside the sheds were not painted using black – even the slightest hint of black in a picture will flatten the whole scene and is undesirable. The colour for the boards was painted using a particularly strong mixture of burnt umber and ultramarine which was washed around the words and names of the fish with a fine brush, leaving the white of the paper to show through to represent the chalk lettering.

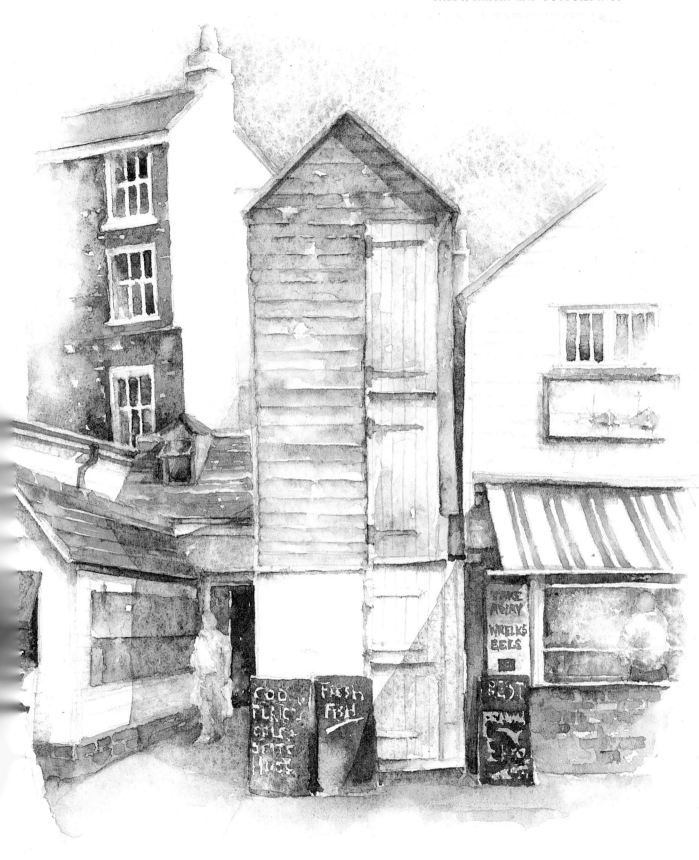

OLD SAIL LOFTS – HASTINGS

Wear and Tear

IT IS OFTEN ONLY ARTISTS WHO SEE THE APPEAL OF OLD, RAMSHACKLE SIGHTS SUCH AS THIS, AND IT IS BEST TO SKETCH THEM WHEN YOU SEE THEM – THEY MAY NOT LAST FOR LONG!

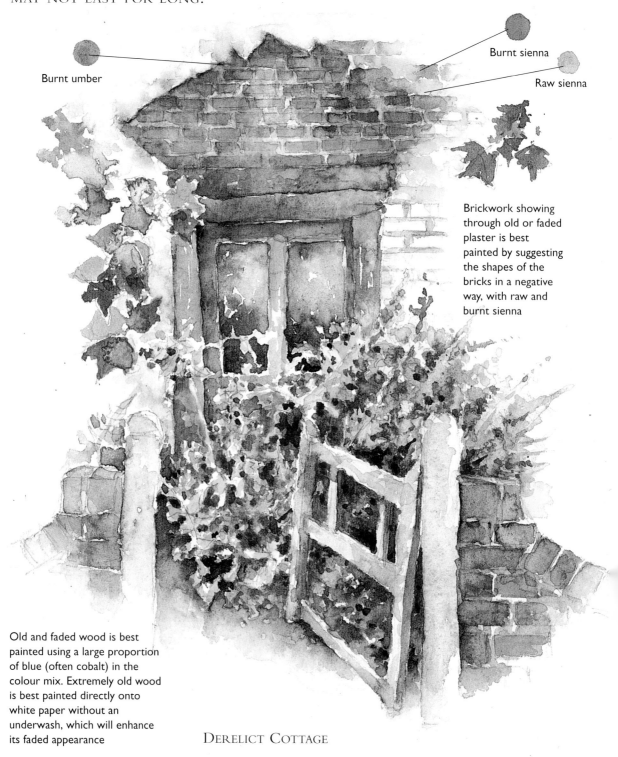

Burnt umber

Burnt sienna

Raw sienna

Brickwork showing through old or faded plaster is best painted by suggesting the shapes of the bricks in a negative way, with raw and burnt sienna

Old and faded wood is best painted using a large proportion of blue (often cobalt) in the colour mix. Extremely old wood is best painted directly onto white paper without an underwash, which will enhance its faded appearance

DERELICT COTTAGE

Often buildings will fall into a state of disrepair or will become so derelict that demolition will be inevitable. These buildings can, however, create some of the most attractive and challenging subjects – although they are perhaps more suitable as sketchbook studies, rather than as finished pictures.

Sketches and detailed studies of subjects, such as the old doorway on the opposite page, can open our eyes to many different painting techniques and encourage us to look at things in different ways. For instance, three approaches were used to record the brickwork in this painting: painting the bricks as positive shapes, and as negative shapes by washing out and by blotting with a piece of kitchen paper.

Firstly, the old burnt and exposed bricks above the doorway where a porch once stood, needed to be recorded as positive shapes; there were so few that they could be recorded individually. Many different tones could be found within the bricks, and the crumbly mortar that held them all in place was lighter than the bricks themselves. A raw sienna underwash was painted and allowed to dry. The bricks were then picked out with a small brush using various combinations of raw sienna, burnt sienna and burnt umber, with just a touch of cobalt blue being added to create the tones for the one or two burnt bricks in the middle.

In the area where the plaster on the walls had peeled and faded (to the right of the door) the shapes of the bricks were beginning to show through, forcing me to use another technique. It was not the bricks on this occasion, however, that required painting – it was the spaces in between, or the negative shapes. This was done with a small brush and a thin, watery mixture of burnt sienna and raw sienna, making sure that the lines of mortar were painted unevenly in terms of tone, reinforcing the patchy, faded look of the old wall.

The next technique is one that can be quite intimidating the first time it is used. To create a washed out and old feel to the brickwork, recently applied colours were literally washed-out (although not washed away completely). This involves judgement that can only be based on a certain amount of experience and, of course, experience can only be gained through practice. So, here's what to do:

Apply the colour for the brickwork and wait until it loses its watery sheen, which will indicate that the water is soaking into the paper and beginning to dry (any excess water will have evaporated). This is the time to drop some clean water with a small brush onto the recently painted bricks. Because the pigment has begun to dry and seal itself within the gum arabic binder, the addition of water will not fully disturb it and wash it away; it will simply reconstitute some of the pigment and dilute it as the water bleeds across the paper, creating a unifying tone in its path. If you want to maintain a little more control over exactly which sections become light and faded you can always blot a little with a piece of kitchen paper.

The old faded door and the broken-down gate were also painted with wet paint, which was allowed to bleed freely and create a patchy appearance, as the stains and grime tend to do on old buildings that are reaching the end of their working lives.

Corrugated Iron

Building materials such as metal are seldom of interest to the artist when they are new; but after some time exposed to the weather, they show signs of decay and can provide fascinating subjects.

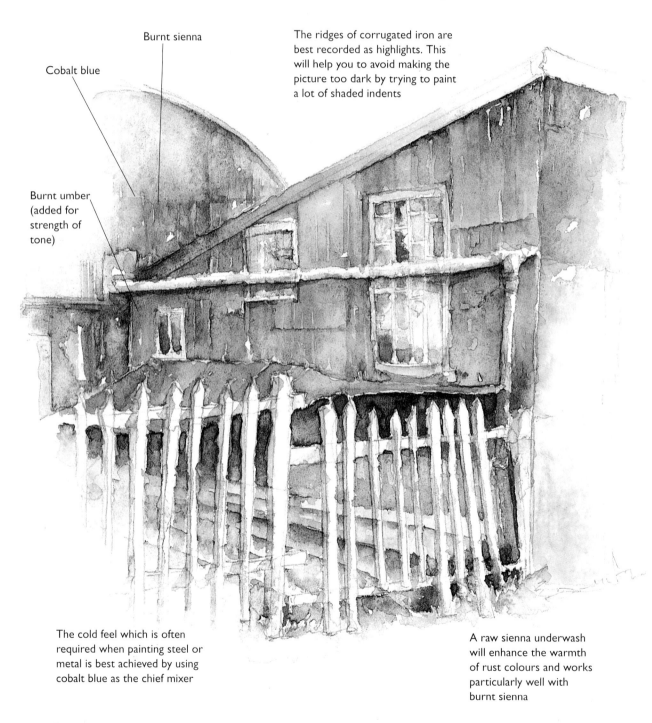

Burnt sienna

Cobalt blue

Burnt umber (added for strength of tone)

The ridges of corrugated iron are best recorded as highlights. This will help you to avoid making the picture too dark by trying to paint a lot of shaded indents

The cold feel which is often required when painting steel or metal is best achieved by using cobalt blue as the chief mixer

A raw sienna underwash will enhance the warmth of rust colours and works particularly well with burnt sienna

CORRUGATED-IRON SHEDS

PROJECT: AUSTRALIAN SHACK

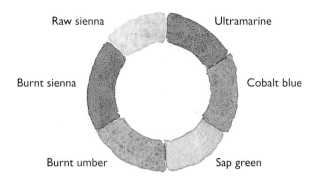

Raw sienna

Ultramarine

Burnt sienna

Cobalt blue

Burnt umber

Sap green

A mixture of warm and cold colours were chosen for this painting. Warm greens and ultramarine for the lush foliage and cobalt blue for the cold steel and sharp sky

Having made a quick pencil sketch of this simple box-like shack (see pages 22/23), the first step was to create the overall mood of the day. A strong, clear, cloudless sky will always give strong, clearly defined shadows on a building, whereas a softer, cloudy sky will often result in more diffused, softer shading within the structures you are painting. If you establish the colours and tones of the background first, this will make it much easier to establish the colours and tones within the buildings.

The background colours chosen were raw sienna, sap green and cobalt blue. First, a wash of thin cobalt blue was painted onto dry paper using a large brush, representing the gaps between the clouds where the sky could be seen. Very quickly, before the paint dried, the areas around the edge of the wash were blotted with a sheet of scrunched-up kitchen paper to create the

feeling of softness around the edges of the clouds. Then, to prevent the clouds from looking pure white, an extremely watery wash of raw sienna (chosen for its warmth of tone) was pulled upwards from the far horizon on the left-hand side in a diagonal sweep, towards the tops of the clouds and, again, the edges were blotted, enhancing the softness.

The trees on the far horizon were painted with a dominant blue tint, reinforcing the effect of distance. This time a medium-size brush was introduced as a little more control was required over where the paint went. The colours used for the meadow that swept down to the shack were sap green with a touch of cobalt blue. These were painted with a medium brush, using a single sweeping brushstroke which was left to dry to a smooth finish, untouched by subsequent applications of paint.

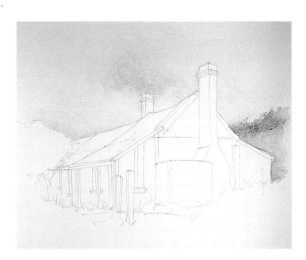

1 The sky was painted using a large brush. A watery mix of cobalt blue was washed diagonally from left to right and then blotted around the edges. A thin wash of raw sienna was applied to the clouds. Background colours were created with cobalt blue as the base colour.

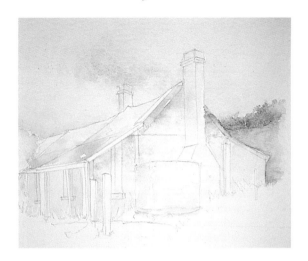

2 An underwash was applied to dry paper using a medium brush: burnt sienna for the roof and raw sienna for the walls. Both colours were painted freely using a lot of water. The new roof panels were left unpainted.

3 The iron roof was developed by applying a second, thicker coat of burnt sienna, using a small brush. Before it dried, clear water was dropped onto the paint to create runs and bleeds. A thin wash of cobalt blue was applied to some roof panels. Shadows were created by mixing burnt sienna and burnt umber, applying them with a small brush and pulling downwards while the wash was still wet.

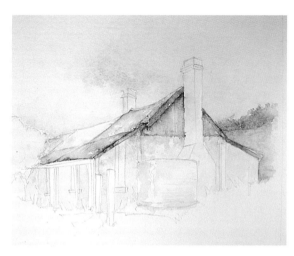

Having established the mood through the use of soft shapes in the sky and background, the next stage was to paint the actual building. As the shacks were built largely of stone and corrugated iron, the choice of colours for underwashes was clear: raw sienna and burnt sienna. They were applied with much water and vigorous brushstrokes to create bleeds and patchy texture.

As the underwash was drying, I decided to work on the roof, recording the textures of the rusty old iron. For this section I chose a small brush, not to record details, but to allow a little more control over exactly where I dropped the water. Most areas required burnt sienna, which was washed on in the appropriate places. While it was drying, a few drops of clear water were dripped from the small brush and allowed to bleed freely,

only occasionally being helped to flow in the right direction.

When this had dried, the shadows underneath the metal sheets were picked out using a mixture of burnt sienna and burnt umber. Using a medium-size brush, raw sienna was applied chiefly to the stone walls, while the burnt sienna was washed across the roof.

The final stage for the roof was to apply a little watery cobalt blue to the less stained sheets of iron, leaving some fine lines of pure white paper to suggest highlights. Some of the panels on the roof were left more or less unpainted at this stage (a few bleeds and overlapping brushstrokes would not have mattered) as they were replacement sheets and did not look so stained by rust and so appeared to be lighter than the sky against which they were viewed.

As the completed roof was drying, I began to organize my colours for the stone walls. As these were really only one colour, only one base colour was required. But as the old weathered stone held a wealth of tones, several additions would clearly be needed.

The underwash on the walls had long since dried, so it was possible to use this to its fullest potential and to work on top of it, using it to represent the lightest tones. The first stage was to create the shadows underneath the old wood and iron awning. The colours mixed for this were burnt umber and ultramarine (which is a stronger blue than cobalt, and results in a deeper tone). Using a medium brush, this paint was applied directly underneath the awning and pulled downwards (in a similar way to the early treatment of the sky), creating a soft gradation within the shading. So as to

enhance the softness, a watery wash of raw sienna was dropped onto the bottom sections of the wall before the shadow paint had time to dry. The two washes met and bled freely, once again creating a patchy texture as they dried. This technique was continued around the stone walls.

The penultimate stage was to complete the woodwork using a watery mixture of burnt umber and cobalt blue, and to paint the shadows of the windows (or where they once were) using the deepest of tones, which were created by mixing only burnt umber and ultramarine and very little water. As with all the shadows in this scene, they were painted with the deepest tone at the top of the window and this was pulled downwards, with the addition of a little water at the base to lighten it.

4 The colours for the stone walls were painted onto the underwash. Burnt umber and ultramarine were used for the shadows. This mixture was painted directly underneath the awning and pulled downwards to achieve gradation of shadow. A watery mix of raw sienna was dropped on using a small brush and allowed to bleed and dry freely.

5 Shadows in the windows were created using the same mixture as the wall shadows, but with less water. A small brush was used to draw the water butt indents and ridges onto a watery undercoat of cobalt blue. Pure burnt sienna was dropped onto the base while it was still wet.

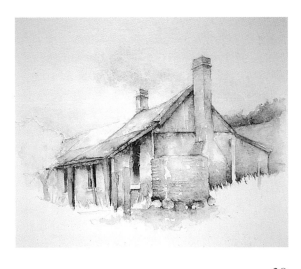

The corrugated iron water butt also had to be included at this stage, using the same colours as the roof, but a different technique: the circular shape required a more clearly defined application of paint. Firstly, using a medium brush, a thin, watery mix of cobalt blue was painted onto the butt, making sure that a line running from top to bottom was left unpainted to act as a reflection. When this underwash had dried, a mixture of cobalt blue and burnt sienna was added, using a small brush to pick out some of the ridges and indents, but leaving the underwash to act as the raised highlighted areas. While this was still wet, some pure burnt sienna was dropped in, to suggest the rust tones.

The final stage was to unify the whole scene by painting the foreground. This required a careful choice of colours – especially the base colour, which would bind all the colours and tones together, making sure that no colour was out of place. As I had used so much raw sienna in the building, and some in the sky, this was an obvious choice for a base colour. To prevent the background and foreground looking as if they were parts of two separate pictures, I pulled a very thin and watery wash of pure raw sienna across the field painted in stage 1. I could then begin to paint the foreground, using a series of mixtures of sap green, raw sienna and ultramarine for the deeper tones, confident that it would match up with those sections already painted.

Traditionally, artists have used the foreground of a painting to elaborate on detail. This is dangerous when painting grass and mud: mud has little detail, only colour; and clumps of grass can easily become too detailed and end up as fancy distractions at the front of your picture. I find that the best solution to this problem is to combine a suggestion of detail with the introduction of variety (and contrast) of tone. On the right-hand side of the building I have ensured that the tone of the stone wall is darker than the grass, making the grass appear to be a very

Raw sienna was dropped onto the clouded area of the sky to reduce the glare of the white paper

Raw sienna was also used as a base colour for the tree and grass to create a more unified feel

Much of the three-dimensional appearance of the painting has been created by the highlights: the fine lines and areas of unpainted, white paper that suggest that light is bouncing off raised areas

light tone. On the left-hand side under the awning, a touch of ultramarine has been added to the sap green and raw sienna mix, strengthening the colour. This produced some grass tones that were a contrast to the lighter tones around the corner, providing visual variety rather than detailed clutter.

AUSTRALIAN OUTBACK SHACK

The painting was completed by adding the tree that leaned out of the composition. This was painted using a mixture of all the colours used elsewhere, as, like buildings, trees should never be painted using a single colour – they, too, reflect the colours and mood of the day.

41

'Au Lapin Agile', Montmartre, Paris

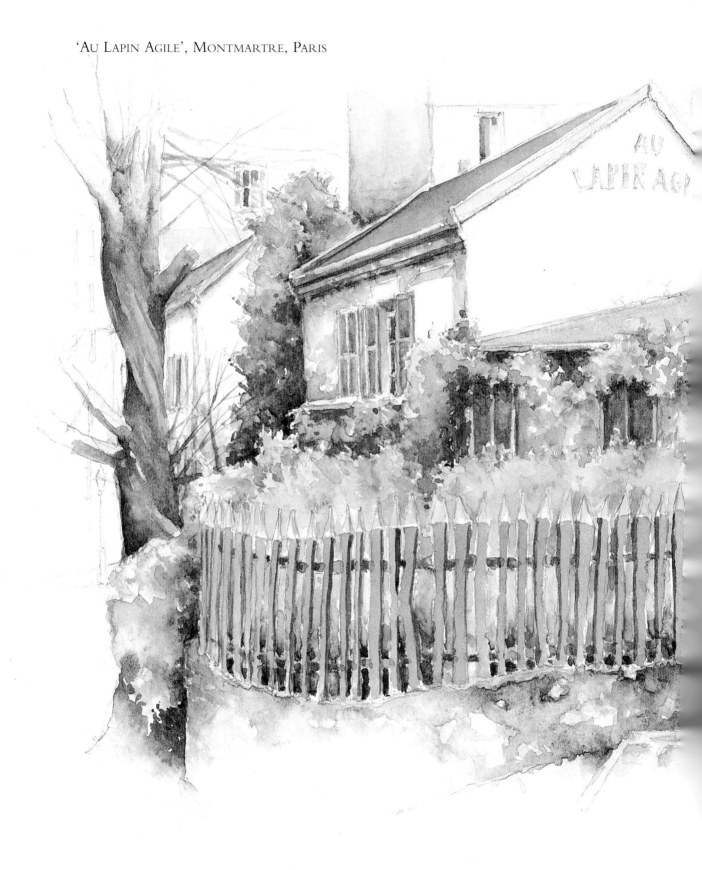

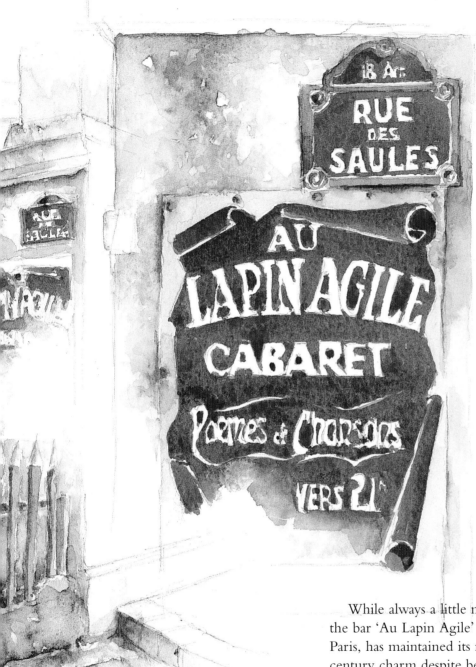

Some buildings that were originally little more than outbuildings have been built onto, extended, and eventually absorbed into the urban environment that has grown up around them.

While always a little more than a shack, the bar 'Au Lapin Agile' in Montmartre, Paris, has maintained its rural turn-of-the-century charm despite being dwarfed by blocks of residential apartments. Its green shutters, creeping ivy, and the shock of bright yellow broom in the front garden all stand witness to its rural past. One particularly appealing feature was the old metal sign with its rust bleeds and typical Parisian blue colouring – best achieved by adding a touch of burnt umber to a very strong ultramarine paint.

COURTYARDS, CLOISTERS AND QUIET CORNERS

The spiritual aspect of architecture – and the peaceful atmosphere that can exist within the quiet environment of buildings that have a long and fascinating history – is an elusive quality to capture in a painting.

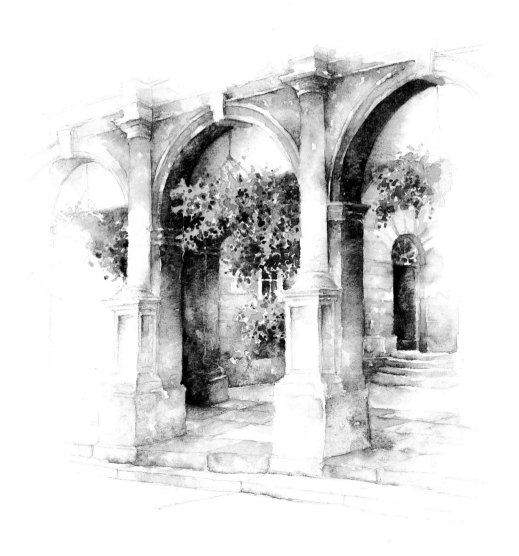

Several of the buildings featured here were found in the southern Mediterranean, while one or two were found much closer to home. Common to all of them is the nature of the purpose for which they were built – to provide open-air spaces for some reason, usually concerned with relaxation or meditation. Courtyards and cloisters have also traditionally been secluded places where people could meet and conduct their affairs, be they spiritual or personal. Tranquillity and privacy, away from the prying eyes of the public, have always been important characteristics of these types of building.

The idea of places of such peace and quiet will always appeal to artists. The other advantage of painting among these types of building is that you will invariably have a limited range of vision – courtyards and cloisters are rarely so large or extensive that you have to become involved in establishing a lengthy perspective. You can, instead, focus on a fairly narrow range of shapes and structures without having to go through a very demanding visual selection process. Often there will be limited places to sit, and this will help to determine your view of the subject. In fact, there is often a very particular consideration in that it will more often be the case that you will be painting the spaces in between parts of buildings, and for this reason you will need to give some serious consideration to the business of light and shade.

You will find that courtyards and cloisters tend to have strong shadows, as they are usually places that are open to the elements and are largely unprotected from the sun. They will often be found in parts of the world where both daily business could be undertaken, and seclusion sought, without too much concern for the weather. This also accounts for the warmth of the stone, and my choice (on the whole) of raw sienna for the undercoat and ultramarine violet as a base colour for the shadows. The sun-drenched flagstones of the courtyards and the bleached stone of the pillars have nearly all been painted using these two base colours. Even the shadier spots have an element of warmth in the light of the day, with only a few additions of the cooler blues and yellows.

This is the very nature of courtyards and cloisters – much warmth and sunlight, tinged with the cool of some welcome shadows.

Mediterranean Steps

T HIS PAINTING SEEMED TO EMBODY ALL THE CHARACTERISTICS
THAT I ENJOY SO MUCH ABOUT PAINTING IN COURTYARDS,
CLOISTERS OR QUIET CORNERS – THE OLD STONE, THE DAPPLED
LIGHT, THE WARMTH OF THE SHADOWS, BUT MOST OF ALL THE PURE
PEACE AND TRANQUILLITY OF THE SETTING.

The strength of the lighting meant that a
warm raw sienna underwash was essential to
act as a base on which to paint the soft-
toned, yet hard-edged, blue-tinged shadows.
When applying an underwash I often favour
blending colours and tones by dropping or
applying paint to a damp surface, forcing the
colours to bleed. With the shadows found in
this type of building, however, I usually paint
onto an underwash and allow it to dry
without any softening of the edges.

The shadows on the steps were painted
with a higher level of attention to detail than
I usually give to a foreground – but they
were clearly visible and begged to be
recorded. So, using a small brush, I mixed
some ultramarine violet with a touch of pure
ultramarine and, having ensured that the
underwash of raw sienna had already dried,
painted the shapes of the shadows over it.

To introduce a feeling of distance and
perspective into the scene, I used the following
brush technique. Using only the tip of the
brush, I started the application of paint at the
top of the steps, lightly touching the surface of
the paper. As the brushstroke came closer to
the foreground, I applied more pressure to the
brush, the result being that the bristles begin to
separate and splay out just a little, allowing
more paint to flow in a wider stroke. Without
easing the pressure on the brush, I pulled the
shadow paint right down towards the bottom
of the composition.

.This technique will result in a wider line
for the shadow in the near foreground, and a
thinner line in the distance, contributing to
the sense of perspective.

Raw sienna was chosen chiefly
for its warm qualities, and was
washed across the walls and
steps using a large brush

Shadows were painted onto
dry paper and allowed to dry
with a hard edge, suggesting
the sharp light of the day

Raw sienna

Rust stains on the drainpipe were
created by running a line of burnt
sienna along one edge and leaving
it to dry with a hard edge

Burnt sienna

Highlights were created by
leaving the fully lit top of the
stone unpainted between two
darkly painted areas, reinforcing
the contrast

Ultramarine violet

Shadows were created by
washing a mixture of ultramarine
violet and ultramarine on top of
a dry wash of raw sienna

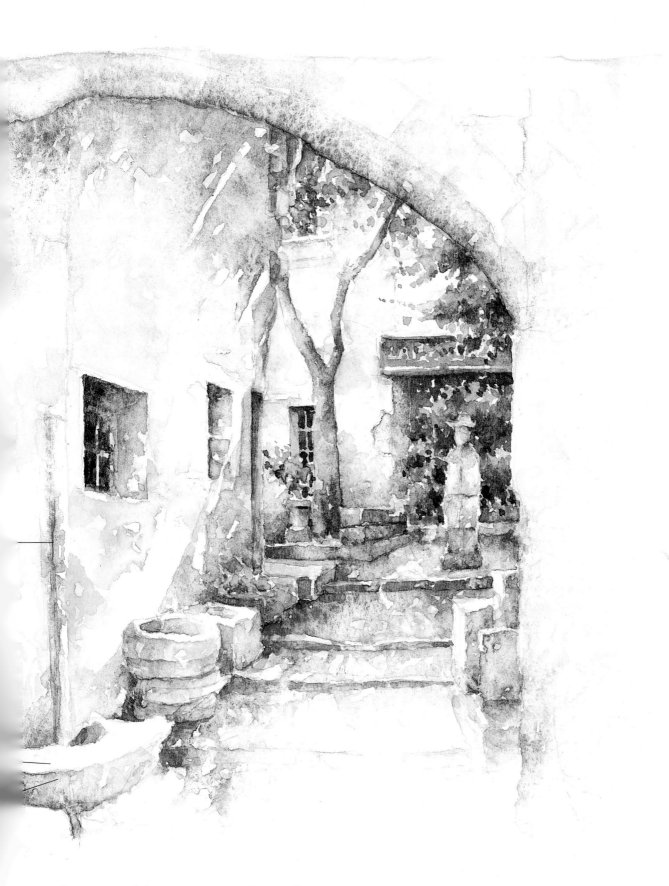

SOUTHERN MEDITERRANEAN STONE STEPS

Courtyards

OURTYARDS ARE OFTEN VERY PERSONAL PLACES, CREATED FOR THE PEACE AND TRANQUILLITY THAT THEIR POSITION OFFERS, WITH AN ABUNDANCE OF LIGHT AND SHADE — IDEAL FOR THE WATERCOLOUR PAINTER.

The colours that I use most frequently in paintings of courtyards are associated with warmth

Ultramarine Ultramarine violet

Raw sienna Burnt umber

Burnt sienna Sap green

Cadmium red Cadmium yellow

Courtyards are often places where colour and interest can be found: pot plants, chairs and tables, parasols, all the trappings of outdoor living. They can be very private places and, as such, are often protected from both the glare and heat of the sun, and from the gaze of strangers by swathes of ivy, vines or trees. The result of this is that one of the most characteristic features of many courtyards will be the dappled light that filters through these protective leafy barriers.

Consequently, courtyards are good places for the study of light (the great intangible aspect of painting) and shadows. The most important points to consider here are that shadows are coloured, and that they hold the qualities of the type of natural light that occurs on the particular day that you have chosen to paint them. I tend to use ultramarine violet as a base for my dappled shadows, particularly for the well defined shadows that are thrown by the intense sunlight of hot climates. The ultramarine violet will often be toned down by the addition of a little cobalt blue; alternatively, it can be strengthened by the addition of a mixture of ultramarine and burnt umber for putting in the deepest, darkest recesses where little light can penetrate.

As for the highlights — the edges or corners where direct light is reflected off an object — I often leave these unpainted, allowing the strength of the white paper to do the work for me. There can be few better contrasts for the watercolour painter to exploit than that of a rich, deep violet shadow against the clean sharpness of a flash of white paper.

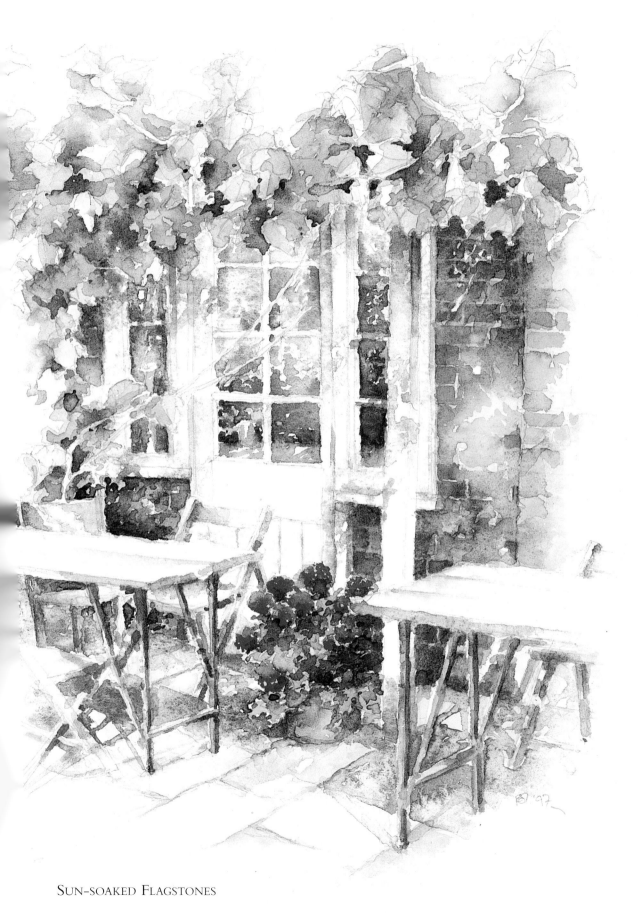

SUN-SOAKED FLAGSTONES

Sunlight and Shadows

THIS SUNLIT COURTYARD IMMEDIATELY CAUGHT MY ATTENTION. THE OVERHANGING TREES AND RAMPANT IVY CREATED A WEALTH OF DAPPLED SHADOWS, AND THE SHARP EDGES OF THE WALLS WERE BROKEN BY SHAFTS OF LIGHT AS THE WARM SUMMER BREEZE FILLED THE AIR.

The warmth of the stone required a light undercoat of raw sienna washed across the walls and floor. While this was still damp, a few drops of burnt sienna were applied. The wet paint bled, allowing the natural qualities of the burnt sienna to create a few patches of warm, textured, reddish stone. The texture of the watercolour paper played a key part in determining the level of bleed of the wet

paint at this point (the paper texture does not, however, affect the tone or intensity of the colours applied to it).

Having established a slightly textured, weathered stone undercoat, the next stage was to underpaint the foliage. This was done with a watery wash of sap green (one of the warmer greens) and cadmium yellow. While this was drying, a watery mixture of sap

An underwash of raw sienna was used to create an underlying warmth, and burnt sienna was added while it was wet to enhance the colour temperature

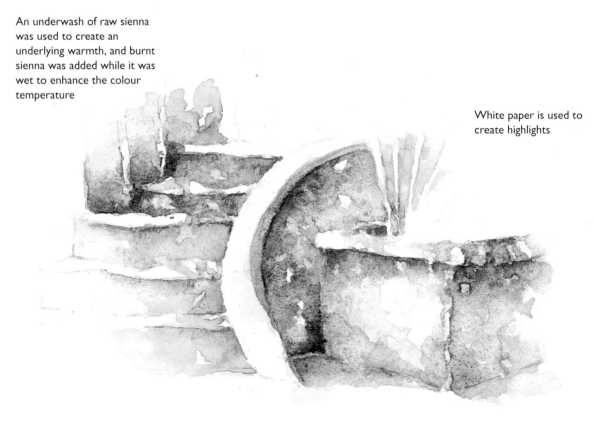

White paper is used to create highlights

STUDY OF STONE STEPS

Shadows were created with ultramarine violet painted on top of raw sienna and burnt umber

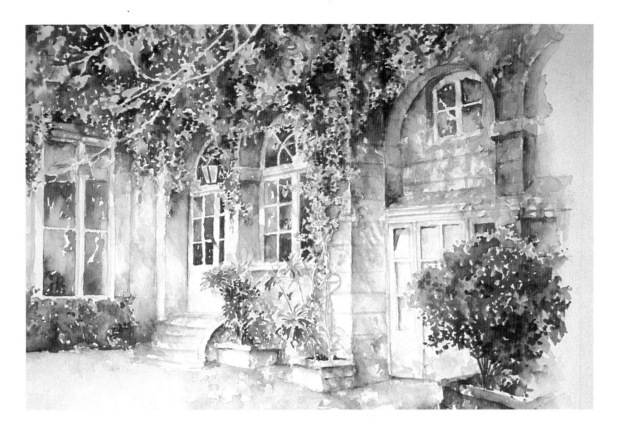

SUNLIT COURTYARD

green, ultramarine and burnt umber was dropped onto the damp paper to create the shaded areas (allowing the paint to bleed, using the same technique as applied to the stonework). With the flat undercoat now complete, it was time to create the more clearly defined shadows which serve to accentuate the highlights.

First, the windows were painted with a mixture of ultramarine and burnt umber, carefully working around the vines that clung to the stone pillars. The intricate lattice of light and shade was beginning to develop. The patterns created by the mottled shadows were painted using a mixture of raw and burnt sienna; the warmth of the paint was intensified when this was pulled over the existing underwash. While this was still damp, a few touches of burnt umber and ultramarine were added to the darkest recesses where the light could not reach. This allowed the penetrating light to appear, by contrast, even lighter still.

The final process was to use the translucent qualities of watercolour to their full. A thin wash of ultramarine violet was painted across the shaded areas as a glaze. The thinness of the wash did little to increase the bulk of the tone but, when washed over the shaded areas of warm stone, it created a glow reflecting the atmosphere of the day. The painting was completed by adding touches of cadmium yellow to the sections of foliage caught by the rays of the sun.

Stone Arcades

HE COVERED PASSAGEWAYS THAT OFFER PROTECTION FROM
THE SUN AND RAIN WITHIN THE PEACEFUL ATMOSPHERE OF
SECLUDED QUADRANGLES AND COURTYARDS MAKE A DELIGHTFUL
SETTING FOR A PAINTING.

There is an appealing, harmonious balance between the order of the man-made geometry of the columns, arches and vaults of the stone arcade, and the natural decay caused by the effect of weather and ageing on the stone arches and pillars.

Drawing arches when viewed front-on is relatively simple, as they are often a semi-circle with a keystone at the top, which acts as a visual anchor. The same principle applies to arches viewed from an angle, but you will need to view the shape as an oval or ellipse and compress it accordingly.

In strong sunlight, the shadows cast by these covered open spaces are often harsh and quite clearly defined. Their overall shapes may be easy to record, but it can be difficult to achieve the subtle balance between lighter and more deeply shaded areas, as the shadows are often gradated. Notice the inside of the arch to the right in the painting: the shadow gradates from very dark at the top, to quite light at the bottom.

The painting on these pages was made in a Cambridge college quadrangle. Here, and in stone arcades around cloisters (which are chiefly religious in origin), there is not usually much man-made colour. Foliage and flowers, trees or a lawn may provide some variety. However, much of their appeal is in their architectural neatness, and the pure simplicity of natural, unadulterated stone.

My palette for this painting is dominated by the natural earth colours: raw sienna, burnt sienna, yellow ochre, and burnt umber. These colours combine well to produce the effects of natural stone – as they should, since the pigments have their origins in minerals extracted from the earth. I take great pleasure in applying these colours freely to the paper in the initial stages of a composition. As they are all of one 'family', they bleed and blend together easily without tipping the balance away from the natural stone colours.

Paintings made in covered stone passageways often use colours predominantly from the cool end of the spectrum

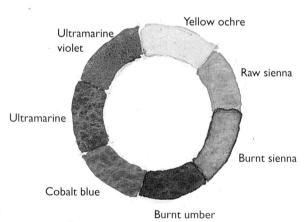

Yellow ochre

Ultramarine violet

Raw sienna

Ultramarine

Burnt sienna

Cobalt blue

Burnt umber

THE CAMBRIDGE COLLEGE QUADRANGLE

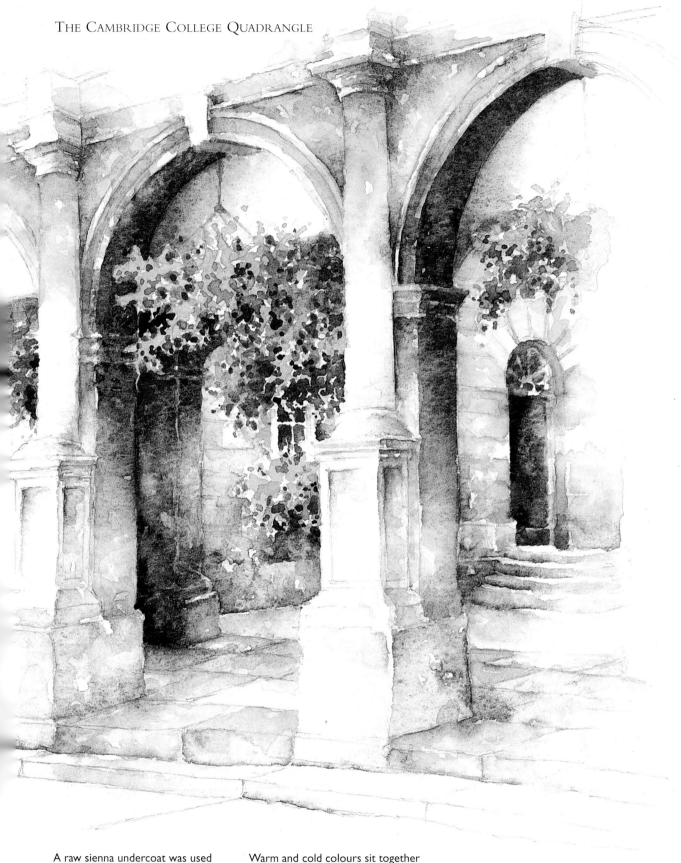

A raw sienna undercoat was used for the stone, with cobalt blue as a base colour for the shadow areas.

Warm and cold colours sit together harmoniously, reflecting the cool shade of stone arches on a hot day

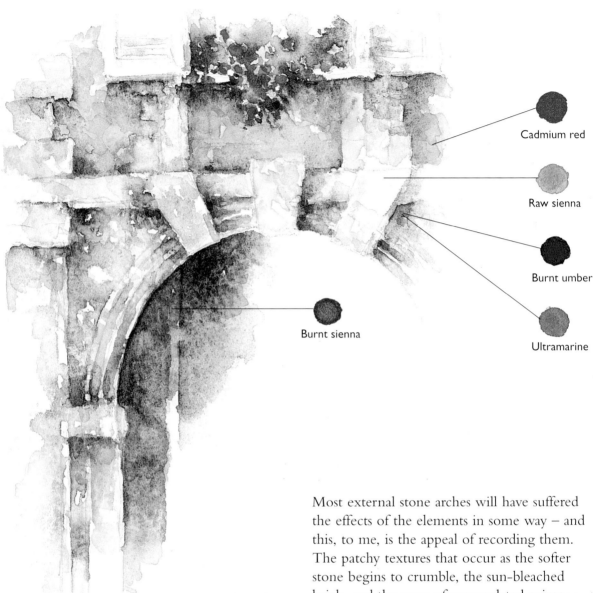

Cadmium red

Raw sienna

Burnt umber

Burnt sienna

Ultramarine

Pure burnt sienna can be added to damp paper to create the effect of rust stains on old stone

Most external stone arches will have suffered the effects of the elements in some way – and this, to me, is the appeal of recording them. The patchy textures that occur as the softer stone begins to crumble, the sun-bleached brick, and the years of accumulated grime – all combine to produce subjects that offer a limited colour range and limitless tones.

These tones are best recorded by a succession of applications of paint to damp paper, generally starting with an undercoat of raw sienna. As this is drying, I drop a watery mixture of the natural earth colours – siennas and umbers – onto the paper, allowing it to bleed and flow freely, recreating as it dries the soft textures of ageing stone. When the paper is fully dry, the architectural details are picked out by the addition of a few shadows painted with a small brush.

PROJECT: SUNBLEACHED CLOISTERS

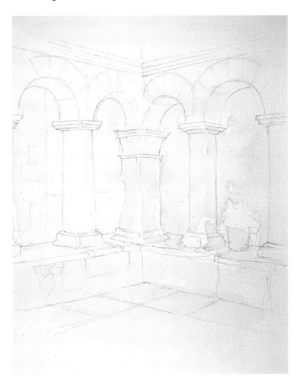

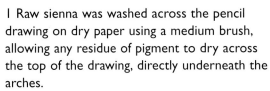

1 Raw sienna was washed across the pencil drawing on dry paper using a medium brush, allowing any residue of pigment to dry across the top of the drawing, directly underneath the arches.

2 A strong wash of ultramarine violet was applied to dry paper directly underneath the arches and pulled downwards, representing the main areas of shading. This was again done using a medium brush.

The soft stone so frequently found in old buildings around the Mediterranean will often appear almost to glow with the radiance and heat of the midday sun. Recording this in watercolour requires a range of yellow and orange tones, purple shadows, and the white of the watercolour paper, all used to their fullest capacity.

The initial underwash applied to the old and crumbling cloisters was raw sienna, which I use chiefly for the warmth of tone that it will give to any washes painted over it. (Raw sienna and yellow ochre can look remarkably similar in paint pans, but have very different qualities when applied to paper – yellow ochre being the colder of the two.)

The strength of the shadows matched the intensity and ferocity of the sunlight, and they were painted in quickly using a wash of

ultramarine and ultramarine violet. Ultramarine is a naturally warm colour, leaning towards the purple end of the spectrum. Ultramarine violet is a particularly good paint to use in these situations as the purple element in the paint has been considerably enhanced. When applied to the raw sienna undercoat, this violet paint develops a slight orange hint, further enhancing the impression of heat that can be seen within the shadows.

Having established the warm undercoat on which to work, the next step was to begin to develop the textures that years of exposure to the elements had created. This process involved applying much water and wet paint in rapid succession. Initially a mixture of raw sienna and a little burnt sienna (used to enhance the warmth of the

55

3 To intensify the area of shading directly underneath the arches, a mixture of burnt umber and ultramarine violet was dropped onto the damp ultramarine violet wash, using a small brush, and allowed to bleed.

4 A mixture of raw sienna with a touch of burnt sienna was washed along the shaded side of the columns onto dry paper, and pulled around the arches with the addition of a little water. A broken line of plain paper was left showing on the central square column, suggesting the reflection of light.

tone) was applied to key sections of the walls and pillars – and then immediately, before this had time to soak into the paper, I allowed a few droplets of water to drop into the paint. This has the effect of pushing the paint outwards, leaving a small diluted spot in the centre. As the paint dries, so the patchy effect of old weathered stone is created.

While this paint was still damp, successive applications of burnt umber and ultramarine were dropped onto the paper. These created a soft range of tones as the colours and tones merged together without discernible outlines. I continued working with this technique until I was happy that I had an adequate range of subtle textures and tones on the stonework. With this stage completed, it was time to work on the shadows, strengthening them and enhancing the contrasts within the picture.

Returning to my initial shadows, mixture of ultramarine and ultramarine violet, I adopted a similar technique, but this time I applied the paint a little more selectively to the areas that required the darkest shading. A wash of the shadow mixture was applied as previously, only this time instead of dropping water into the centre, I used an even darker mixture enhanced with a little burnt umber and dropped it onto the wet paint, creating even darker tones.

The final stage to complete this study was to enhance the shadows around the architectural details to make the ledges and architrave of the columns appear to stand out. I also made sure that some white paper was still showing through along the ridges and edges, enhancing the contrast between the dark and the light elements of this sun-soaked corner of a Mediterranean village.

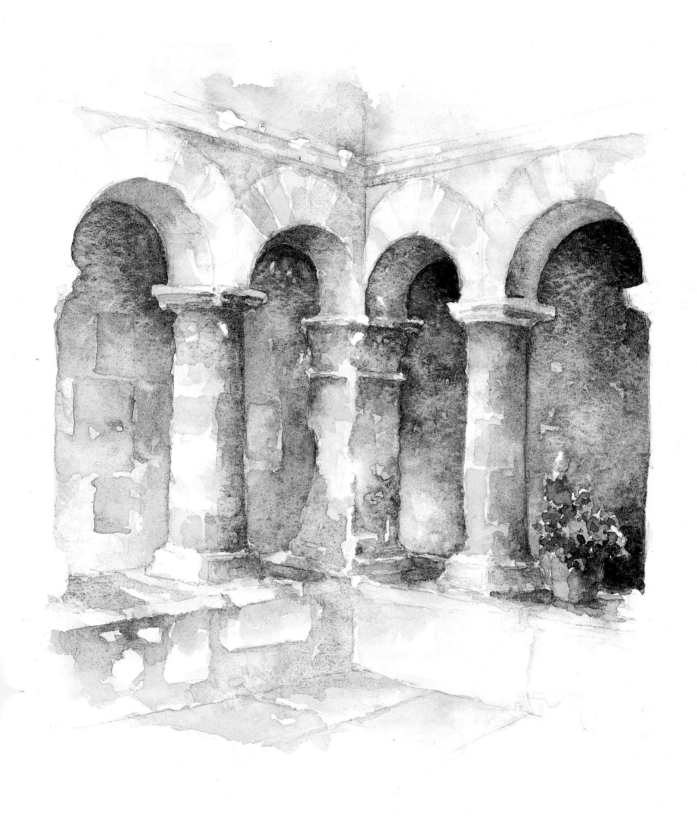

CLOISTERS IN MIDDAY HEAT

Shaded Spots

EARLY IN THE MORNING, BATHED IN THE CHILL OF THE EARLY SPRING LIGHT, THIS QUIET COURTYARD CAFÉ SCENE HELD AN AIR OF ANTICIPATION.

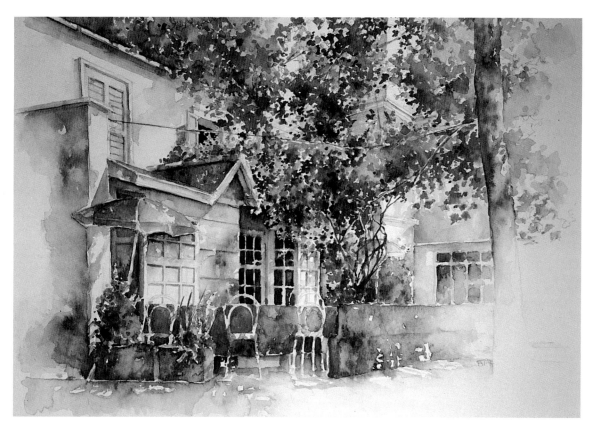

SHADED CORNER CAFÉ

The sun was just rising above the skyline which dwarfed this hidden corner café, catching a few leaves and giving an indication of the growing mood of the day to come. While the windows and doors were closed tight, the heady smells of coffee and warm bread rose on the sweet morning breeze – an indication that the preparations for the new day were under way.

To capture the atmosphere of the day required careful treatment. Sunlight shone in abundance, casting sharp shadows, but it was early in the morning and early in the year so there was still a cold feel to the air and a cold blue tinge to the scene.

The shadows provide the main interest in this composition, and they are entirely the result of the ivy and overhanging leaves that spanned this quiet corner. It seemed appropriate, therefore, to make the foliage the starting point of the painting. It was underwashed with a watery mixture of sap green and cadmium yellow. A mixture of ultramarine and burnt umber was applied to the shaded areas while the paint was still damp, allowing a bleed that would dry

SKETCHBOOK STUDY OF SHADOWS

The cool shadows found in this quick sketch were painted with a mixture of cobalt blue and burnt umber, and washed onto dry paper to maintain their clarity of shape

Shadows cast by architectural features are important on buildings and add further clarity

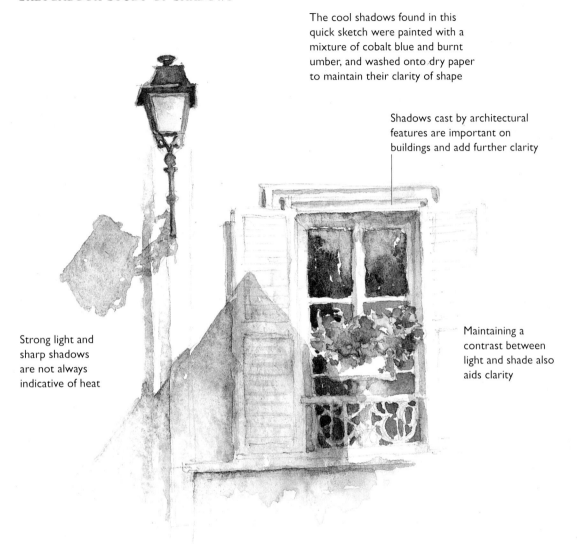

Strong light and sharp shadows are not always indicative of heat

Maintaining a contrast between light and shade also aids clarity

without hard edges, creating a foundation on which to paint the more highly detailed shimmering leaves later on.

Once the basic tones and shape of the foliage had been created, the shadows thrown across the walls could be convincingly established. These were painted in with a touch of cobalt blue and burnt umber, enhancing the blue and echoing the coldness of the light. This wash was pulled across the red tablecloth and onto the stone ground, which had the effect of creating a cold purple tint in the shadows.

This painting was completed by creating the deeper, darker recesses which, in turn, pushed the highlights to the fore, creating the shafts of light so important to this scene. As the colours had been established, only the tonal values needed accentuating.

One of the fundamental principles of watercolour painting was used to good effect in this painting: that of allowing the white of the paper to work for itself. While the shadows were created by a build-up of colour washes, the shafts of light were created by painting around pure white paper.

59

Stone Vaults

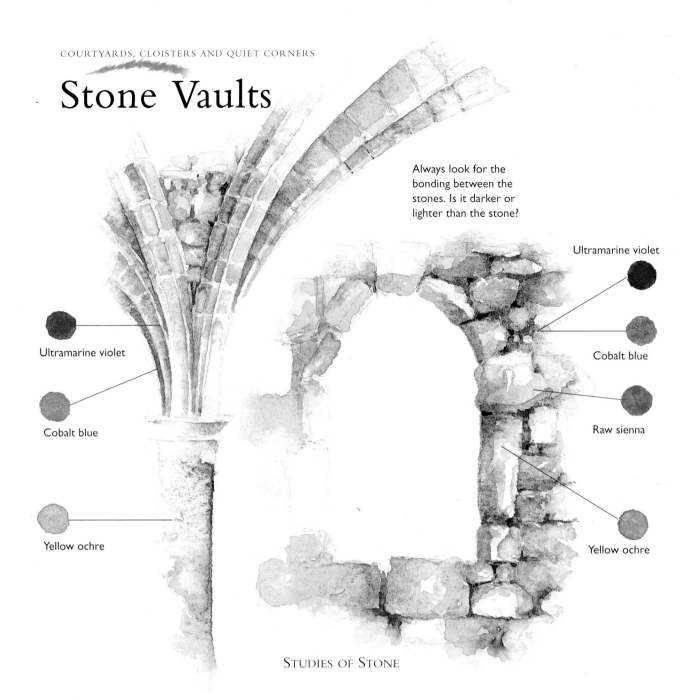

Always look for the bonding between the stones. Is it darker or lighter than the stone?

Ultramarine violet

Cobalt blue

Yellow ochre

Ultramarine violet

Cobalt blue

Raw sienna

Yellow ochre

STUDIES OF STONE

S TONE IS A HIGHLY VARIABLE SUBSTANCE IN TERMS OF COLOUR, AND ITS COLOUR CAN VARY ACCORDING TO THE TIME OF DAY, OR THE DIRECTION OF THE LIGHT.

Stone holds a vast array of colours, many of which only become evident in certain lighting conditions. The blue and violet tones are often more obvious in poorly lit conditions, whereas the yellows and oranges are best seen in direct sunlight.

It is a good idea to have a close look at the stonework that is in front of you before you start painting – especially the way it is

held together. Some stone structures have a light cement or mortar between the individual stones – especially interior vaults and columns. Others have a much darker bonding, generally the result of years of accumulated grime, and this is more often found on old stone walls. Sometimes both will occur side by side within the same building. As always, observation is the key.

PROJECT: VAULTED PASSAGEWAY

1 The pencil drawing was treated to a series of watery washes of yellow ochre and raw sienna applied onto dry paper using a medium brush, and allowed to mix freely. Some parts were blotted with a piece of kitchen paper to create textures.

2 The base colour of the shadows was created by painting of a mixture of ultramarine violet and cobalt blue onto the walls and floor. A medium brush was used to apply this paint onto dry paper, allowing a degree of clarity of shape to develop.

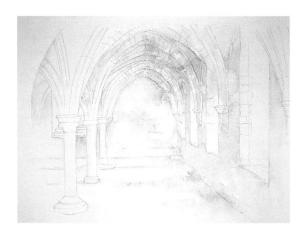

The almost celestial light created in the coolness of this stone passageway glowed with the soft and gentle warmth of the evening sun. The key to recording the scene inside this building lay in careful observation of the shadows and shading – especially the colours of the shadows.

My main area of concern was with the softness of the light and shade. This required the gradual build-up of a number of tones, most of which contained an element of blue or violet.

The shadows on the ground and walls needed to contain both the stone colour as well as the perceived colour temperature of the light. This meant that the whole scene had to be painted with a delicate balance of cold blues and yellows and warmer oranges.

The basic stone undercoat was created by applying washes of the cool yellow ochre and the warmer raw sienna. These were allowed to bleed freely, helping to create some stone textures in the process.

When this undercoat had dried, the basic shadow undercoat was applied. This was a combination of the cool cobalt blue and the warmer ultramarine violet.

Having established the stone underwash and the basic tone of the shadows, the finer details could be painted in – chiefly, the intricate pattern of brickwork on the vaults and the textured stone on the walls. The stone texture on the walls was created by applying a paint mixture of yellow ochre and raw sienna to the stonework and then dropping cobalt blue and ultramarine violet onto the damp paper. As the paints separated and dried, so they started to create the effect of textures in the stone.

The vaults were painted with a little more

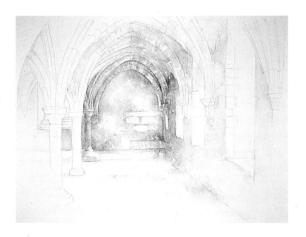

3 Having completed the base coat, the next stage was to establish the colours and textures of the stone, starting at the furthest wall. Burnt umber, cobalt blue and raw sienna were applied to dry paper and allowed to mix freely on the paper, blotting where appropriate to create the lightest stones.

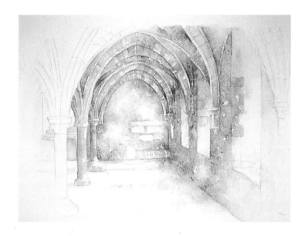

4 A small brush was used to paint cool blue colours and tones onto the vaults in the ceiling, gradually working towards the foreground. This process was carried out on dry paper to allow more control of the paint.

attention to specific detail. The blue, violet and yellow stones were picked out and painted, ensuring that the darkest set of tones appeared in the immediate foreground. A carefully chosen selection of cobalt blue, ultramarine violet and yellow ochre was used, both individually, and occasionally mixed together.

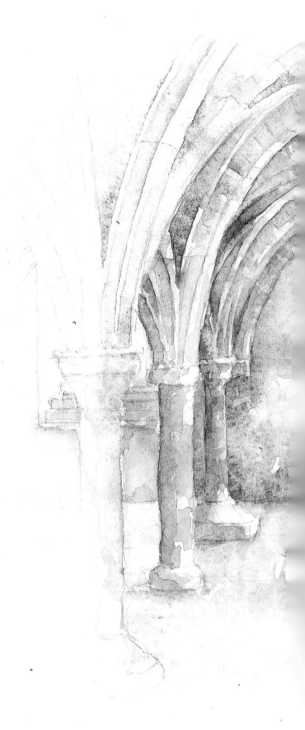

VAULTED PASSAGEWAY, BATTLE ABBEY

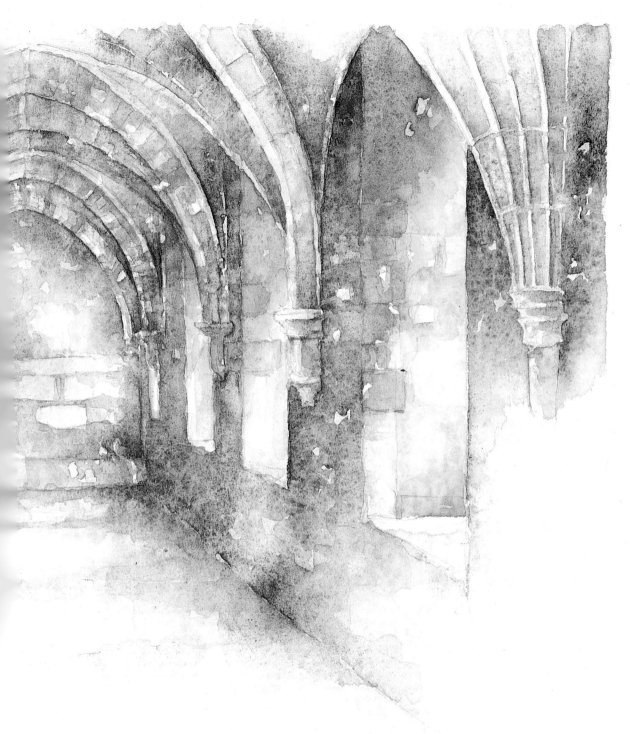

The final stages of this painting involved enhancing the shadows directly underneath the window arches and on the ground. This was achieved by allowing a range of colours to mix freely on the paper. Cobalt blue and ultramarine violet were mixed with water, then dropped onto the areas requiring the darkest shading, and allowed to bleed together. (The mix will dry unevenly, resulting in a more realistic look on the stone.) For areas where the most extreme darks were required, a mixture of cobalt blue and burnt umber was dropped onto the shadow mix, enhancing the delicate contrast between light and shade from the evening light.

63

DOMESTIC BUILDINGS

*W*hen painting peoples' homes we are not only recording the architectural structure and details of the building, but also sketching an aspect of somebody's life, noticing the eccentricities and personalised features that make a house into someone's home.

From the humblest hut to the most ornate of palaces, a home will reflect something about its owner. I have necessarily had to limit the subjects in this chapter, and so have chosen a range of buildings that I feel will be most useful to you in terms of the watercolour techniques used, when you are painting your own or other peoples' homes. Some of the buildings display quite obviously the individual characteristics of the owners, while others retain a sense of anonymity.

While the main fabric of a building will rarely be changed by its owners, the features such as doors, doorways, railings and windows can be altered quite easily and therefore allow residents to personalise their homes. For this reason I have devoted some pages to making studies of windows and doorways. Terracotta pots and flowers are frequent additions to urban and rural houses, and can add a welcome flash of colour to an otherwise dull wall. Also, look out for the decorative architectural elements – plaster surrounds and decorative brickwork can frequently be found in residential buildings, and are attractive features to paint.

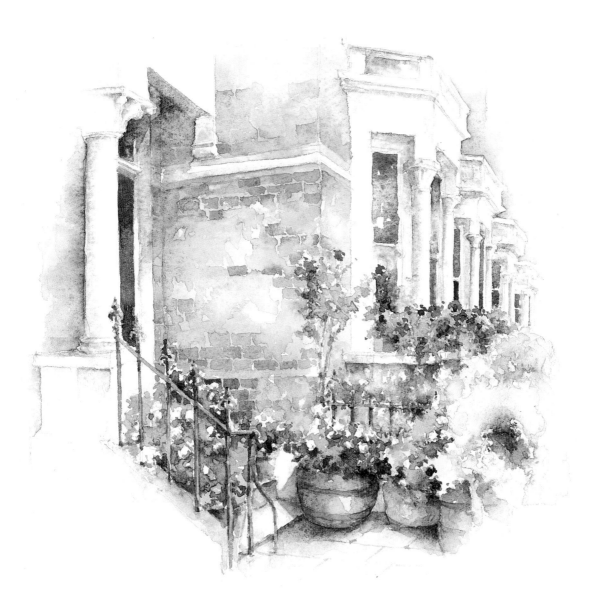

The environment in which a building is set will also give clues to its individuality, whether it is the rural setting of fields, the leafy surroundings of a garden, or a built-up high street.

Do not forget, too, the reality of the trappings of our age, such as the motor car. I will often include cars and vans, even traffic meters when they clearly form part of the composition. Obviously, we as artists have a choice to make as to whether or not they will enhance the visual quality of our pictures, but I do not always choose to move a parked car (artistically!) just because I am focussing on painting or sketching somebody's home. It might be the householder's car, and as such, probably deserves to be part of the picture.

Narrow Streets and Alleyways

THE STEEPNESS OF THE MEDIEVAL ALLEY, THE TEXTURES IN THE STONE, AND THE PICTURESQUE QUALITIES OF THE WINDOWS WERE VISUALLY APPEALING BY THEMSELVES IN THIS SOUTHERN MEDITERRANEAN BACK STREET. BUT WHAT MADE THE SCENE EVEN MORE APPEALING FOR ME WERE THE SIGNS OF HUMAN HABITATION: THE WASHING HANGING ACROSS THE STREET, AND — ANCHORING THE ENTIRE SCENE FIRMLY IN THE TWENTIETH CENTURY — A MODERN ROAD SIGN PROHIBITING VEHICLES FROM ENTERING THIS RESIDENTIAL HAVEN OF PEACE AND TRANQUILLITY.

This painting was made in the studio, created from references gathered on site. As such, it is possibly a little less accurate, but a lot more finished than it would have been if I had painted it on the spot.

The main technique used in this picture was that of washing and blotting. It is a technique that I will usually only use in the studio as it depends very largely on having a fairly constant temperature to allow you to measure or judge the rate at which the wet paint will dry. The textures in the brickwork and the walls were created by washing a wild and wet undercoat of raw sienna (ideal for the Italian stone) and, using a large brush, as this is beginning to dry, dropping on some darker colours – usually burnt umber, burnt sienna and ultramarine – and allowing these paints to bleed together. As they begin to dry, hard lines or watermarks will begin to form. Some of these I blot out using a piece of scrunched up kitchen paper, and others I leave to dry by themselves. When these patches have dried I select a few of them and, using a small brush and a mixture of burnt umber and a touch of ultramarine, paint around the watermarks (or light, blotted shapes), creating areas that are suggestive of flaking plaster or uneven stonework. I will leave some of these to dry with a hard edge, and I will drop some water onto others to create a bleed, or maybe blot the edge. I work on in this way until I am satisfied that the area I am painting is textured enough.

An unusual aspect of observation came into play in this composition. Because the street was so steep, I found myself looking up directly underneath the eaves and arches, gaining a fuller view than usual. These areas also needed a substantial amount of shading and for this I used burnt umber, raw sienna and cobalt blue. Having applied the paint with a medium brush I pulled it downwards along the wall, adding clear water to dilute the tone, and allowing it to bleed freely and to dry with a little blotting where required.

The final aspect of this composition involved putting in the figure walking towards the arch, reminding us of the purpose of the buildings, and giving scale and focus to the composition. This is something that I look at more closely in the final chapter of the book.

ITALIAN ALLEYWAY

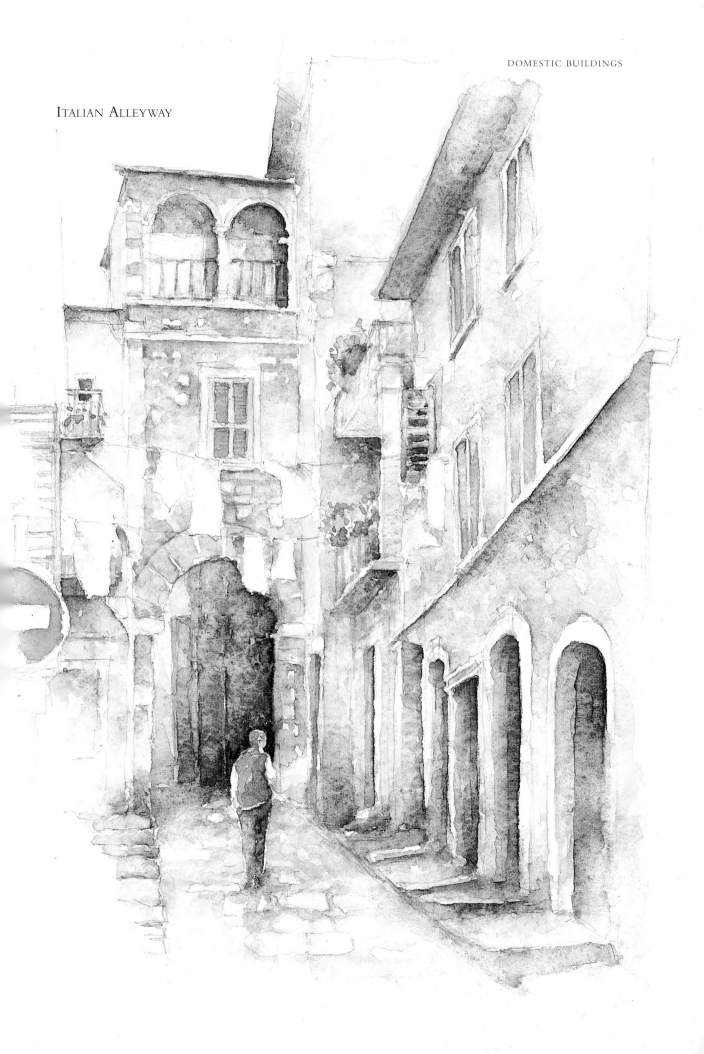

Windows and Doors

WITHOUT WINDOWS AND DOORS, A BUILDING IS LITTLE MORE THAN AN UNINHABITABLE SHELL. IN FACT, IT IS OFTEN THESE FEATURES THAT PERSONALIZE BUILDINGS AND TURN THEM INTO RECOGNIZABLE HOMES.

Windows and doors give more clues to the human element than most other parts of a building, and it is often this that is most interesting to artists. The intricacies of the decorative ironwork on this door study were a challenge to record and needed considerable sketching with a pencil before I set about working in paint. But the appeal was not so much the difficulty of the

challenge of recording the door, but the story the door could tell. The exposed wiring, the lack of maintenance, the paintings hanging outside – all of these things tell a story of many different lives. But who, why and when? As a study, the peeling paint and the damp plaster were a pleasure to record, but the question as to what went on behind that door was never far from my mind.

Textures of faded plaster were created by dropping water onto damp paper, allowing the paint to dry with a hard line

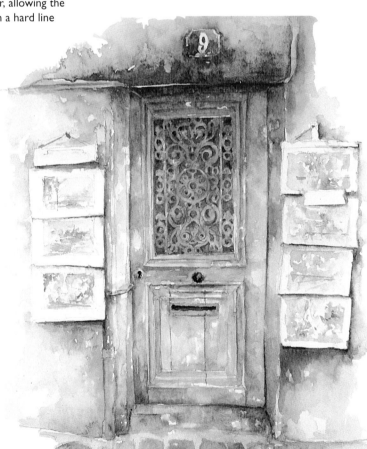

The deepest greens in this study were achieved by mixing sap green with ultramarine and a touch of burnt umber

The fine detail in this study was applied with a fine brush, but only when the underwash had dried fully

GREEN DOOR

68

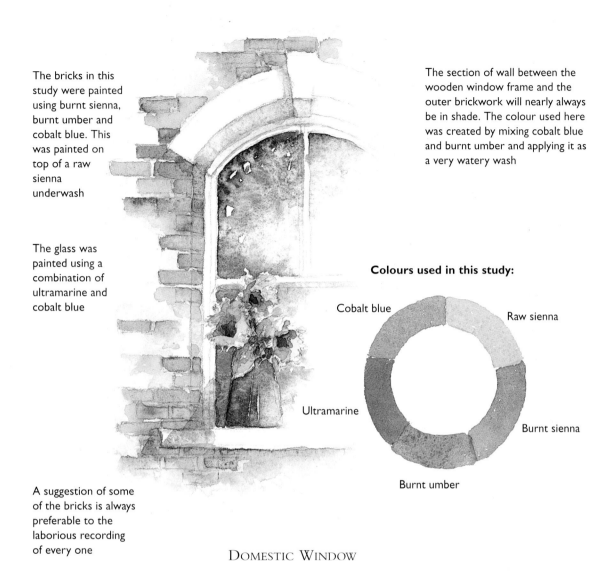

The bricks in this study were painted using burnt sienna, burnt umber and cobalt blue. This was painted on top of a raw sienna underwash

The glass was painted using a combination of ultramarine and cobalt blue

A suggestion of some of the bricks is always preferable to the laborious recording of every one

The section of wall between the wooden window frame and the outer brickwork will nearly always be in shade. The colour used here was created by mixing cobalt blue and burnt umber and applying it as a very watery wash

Colours used in this study:

Cobalt blue

Raw sienna

Ultramarine

Burnt sienna

Burnt umber

DOMESTIC WINDOW

Windows, like other parts of a building, tend to have typically indigenous or national characteristics. But the one thing that most windows have in common these days is that they are set back into the fabric of the wall.

In most domestic buildings, glass is held in a wooden frame, and this is set into a brick, stone or wooden wall. The study above illustrates clearly both the construction (a wooden frame set into a brick wall) and the human element (the vase of flowers) which increases the appeal of the study.

The brickwork in this study was painted on top of a raw sienna underwash. When this had dried, the bricks were painted using

a small brush and a selection of colours mixed with burnt sienna, burnt umber and cobalt blue. When this had all dried, I put in the shadow that tells us that the window frame is set back into the wall. Using a medium-size brush and a mixture of cobalt blue and burnt umber, the paint was pulled across the wooden frame and the inner brickwork. A harsh line along an inset such as this will always suggest a strong shadow and enhance the three-dimensional appearance of a wall into which windows and doors are set. Similarly, a strong shadow underneath a window ledge reinforces and enhances this effect.

Terraced Houses

A TERRACE OF TOWN HOUSES CREATES A CHALLENGE TO THE ARTIST IN TERMS OF THE LINEAR PERSPECTIVE OF THE DRAWING, AND THE TONAL PERSPECTIVE OF THE PAINTING. CLOSE OBSERVATION OF SURFACE TEXTURES, REFLECTIONS IN WINDOWS AND DETAILS SUCH AS FLOWERING WINDOW BOXES WILL GREATLY ENHANCE THE COMPOSITION.

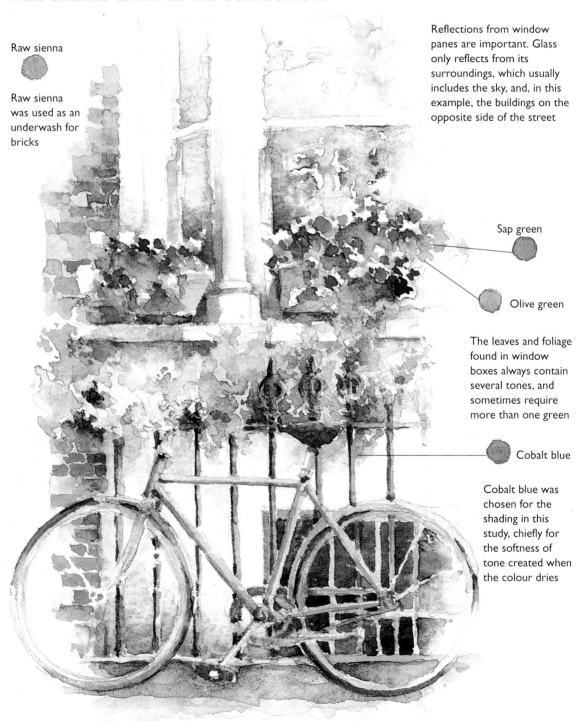

Raw sienna

Raw sienna was used as an underwash for bricks

Reflections from window panes are important. Glass only reflects from its surroundings, which usually includes the sky, and, in this example, the buildings on the opposite side of the street

Sap green

Olive green

The leaves and foliage found in window boxes always contain several tones, and sometimes require more than one green

Cobalt blue

Cobalt blue was chosen for the shading in this study, chiefly for the softness of tone created when the colour dries

PROJECT: TERRACED HOUSES, LONDON

The complexity of a long terrace such as the one in London's famous Chelsea district shown on the next page, requires a solid structure upon which to work if it is to succeed. A careful pencil drawing was made, ensuring that the perspective was accurate and that all the vertical lines remained parallel (see page 22).

Once this was established, the paint could be applied. Being largely brick and painted plaster, little colour was needed for the buildings – just a range of brick tones, shadows and reflections. The initial stages involved washing a mixture of burnt sienna with a touch of burnt umber across the walls, working onto dry paper to allow an element of control over exactly where the paint went. As usual with large areas of walls – be it brick, stucco, corrugated iron or wood – a totally smooth finish is rarely required. A patchy look will give a more realistic representation of a large wall, and details can be suggested in the next stages.

Some scenes benefit from strong lighting and harsh shadows, but the subtle interplay of light on the regular lines of this terrace was, I believe, much more attractive. The windows and the plastered surrounds were painted with cobalt blue to create the effect of soft lighting that occurred on the day.

To create the effect of tonal perspective, I started with the furthest window and gradually worked towards the foreground, ensuring that each application of paint for each individual dwelling was a little darker than the previous one.

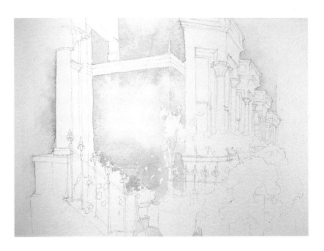

1 All the vertical lines in the pencil drawing were checked to see that they were parallel before any paint was applied. A mixture of burnt sienna was washed onto the wall with a medium brush, the wash acting as an undercoat for the brickwork.

2 The shadows and reflections from the window and the plaster surrounds were painted using a small brush and cobalt blue. Working from the furthest to the nearest window, each was painted a slightly darker tone than the one before to emphasize the effect of perspective.

DOMESTIC BUILDINGS

Town Houses, Chelsea, London

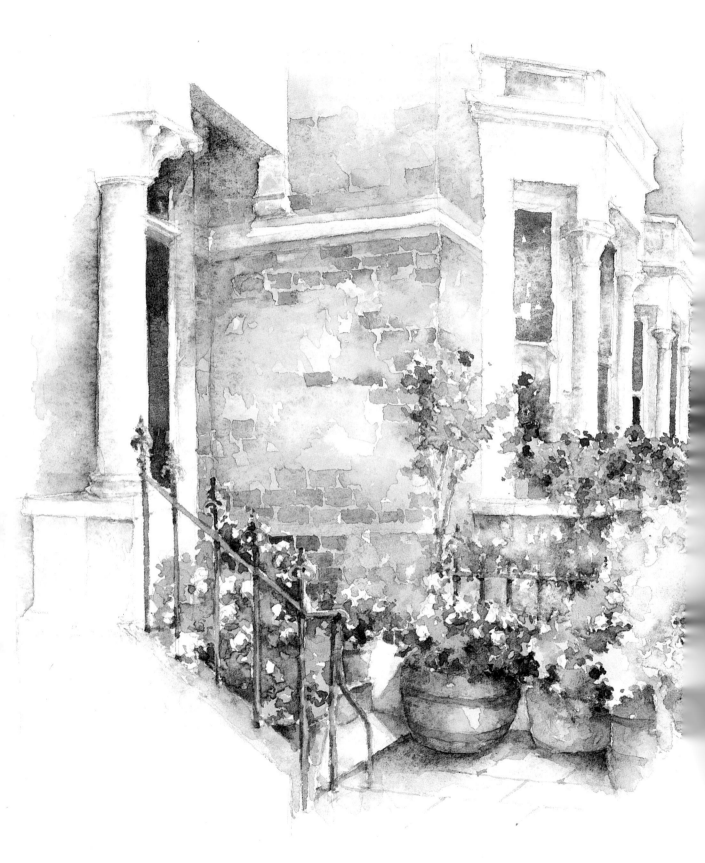

3 Cobalt blue with a touch of burnt umber was used to create the shadows around the door. These colours were applied with a medium brush and pulled down the line of the pillar on the shaded side. Pure water was then washed along the middle of the pillar to prevent a hard edge occurring on the shadows.

4 Assorted combinations of burnt sienna, burnt umber and ultramarine were used for the bricks, which were suggested by applying brushstrokes intermittently with a small brush. Water was dropped onto a few selected bricks to create a bleed.

You will recall that an element of shading was added to the plastered window surrounds with cobalt blue, and the same method was used for the door frame and the decorative pillars. Some shading was also required for the steps, and this was created by mixing the same cobalt blue with a touch of burnt umber for depth.

The most challenging aspect of this scene was the large brick wall facing me. This was a vital part of the composition, visually framed by the windows, door and plants, but it held little interest in itself.

It would have been neither possible nor desirable to have recorded every single brick of the wall, so the technique of suggestion was introduced. There are few rules for this technique. You, the artist, must make some decisions about how many bricks to suggest

and exactly where to put them. Some advice, however, can be offered about how to suggest the bricks. I advise that you use three colours – one mix of pure burnt sienna, one mixture of burnt sienna and burnt umber, and one mixture of burnt umber and ultramarine to represent the burnt bricks that occur in walls. Apply these using a small brush as a single stroke, occasionally dropping a little water onto the edge of a 'brick' to create a bleed. Suggestion is always best with watercolour, rather than labouring on details, in order to avoid a contrived appearance.

Finally, the foliage and flowers in the pots and window boxes were loosely painted, allowing the white of the paper to stand for the white blooms, and ensuring that the colours harmonized with the composition.

Parisian Square

The lack of bright colour in this Parisian square meant that much emphasis had to be placed on achieving a wide range of tones

The coldness of the day required the choice of cold colours. Cobalt blue was the natural choice for the awnings, and this was also used for the shadows

The patchy textures of the walls were created by applying thin wet paint in patches onto dry paper and allowing it to dry without making any attempt to blend the colours

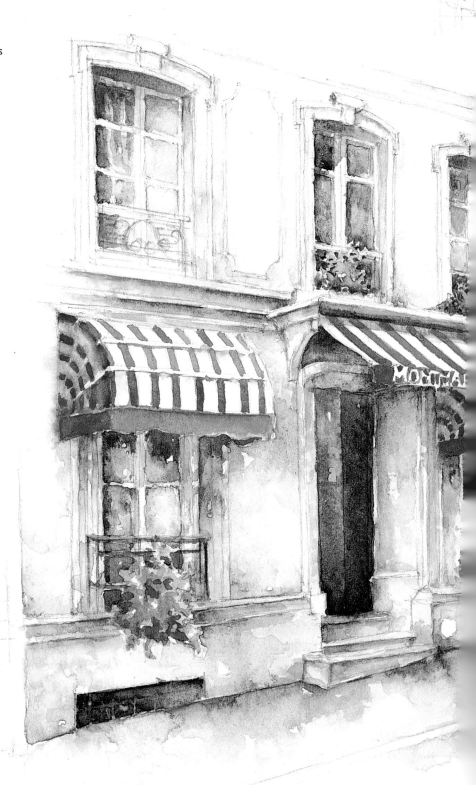

HOTEL IN THE PLACE ÉMILE GOUDEAU

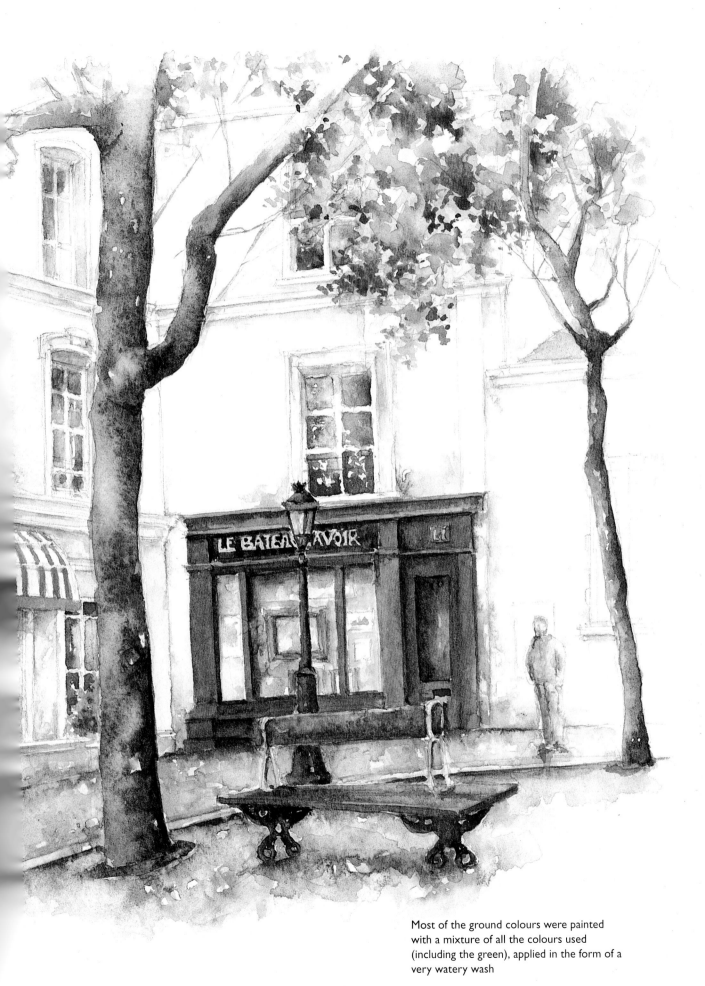

Most of the ground colours were painted
with a mixture of all the colours used
(including the green), applied in the form of a
very watery wash

75

American Town Houses

THE COMBINATION OF WOOD PANELLING, WHITE WINDOWS AND PORCHES CAN CREATE A WONDERFUL ANGULAR INTERPLAY OF LIGHT AND SHADE IN THESE BUILDINGS, AND IT IS WORTH WAITING FOR A GOOD, BRIGHT, SUNLIT DAY TO PAINT THEM IN THEIR FULL GLORY.

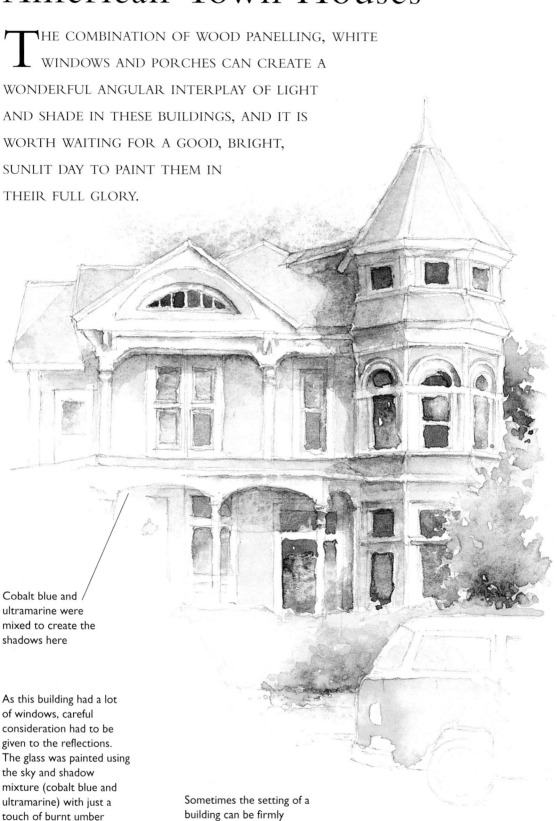

Cobalt blue and ultramarine were mixed to create the shadows here

As this building had a lot of windows, careful consideration had to be given to the reflections. The glass was painted using the sky and shadow mixture (cobalt blue and ultramarine) with just a touch of burnt umber

Sometimes the setting of a building can be firmly established by including objects such as cars (or figures) in the composition

DENVER TOWN HOUSE

PROJECT: HOUSE AND GARDEN, COLORADO

1 Background treetops were painted using a medium brush, and by dropping cadmium yellow onto damp sap green, followed by a little cadmium red. The tops of the trees were then blotted to achieve a feeling of softness.

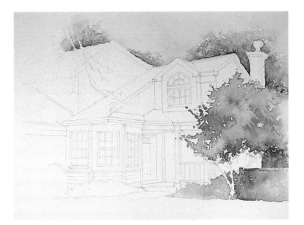

2 The foreground tree was painted using the same technique as before, but this time the cadmium red was applied when the tree was dry to maintain its strength of colour; also, the top of the tree was not blotted.

The first part of this painting involved establishing not just the mood of the day, but also the season. Many North American states are world-renowned for the way that their landscapes and woodlands blaze with colour in the fall. It was important, therefore, that this building, set among such rich and vibrant colours, was initially established against the correct backdrop of colour.

The treetops visible in the far background were painted with an unusual selection of colours – sap green, cadmium yellow and cadmium red. Firstly, a wash of sap green was applied. While this remained damp, a little cadmium yellow was dropped onto the tops of the trees and allowed to bleed downwards, with a little blotting around the very top of the trees to create a feeling of both softness and distance. Before this mixture had time to dry fully, a very small amount of cadmium red was touched into the damp paint and,

again, allowed to bleed freely. The trees and bushes did not require any detail, but they were strong in their depth of tone. They were painted by mixing sap green and a touch of ultramarine, then adding some burnt umber to remove the greenness, while enhancing the depth of colour.

The tree in the immediate foreground was painted using the same technique of applying washes and then dropping some colour on once the paint had begun to dry – but this time, the final coat of cadmium red was held back until the paint on the tree had dried fully. By applying the paint to dry paper, with no water or other colour to dilute it, the strong, deep red was created that can be seen on the left-hand side of the tree – the fiery colours of the garden.

Having created the environment in which the house stood, it was time to get to work on the house itself.

77

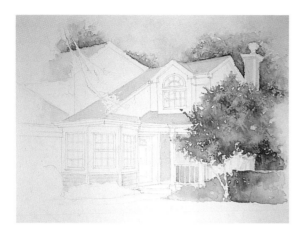

3 An underwash was applied to the building using a medium-size brush and a mixture of burnt sienna with a touch of the cadmium red and yellow that had been used in the trees. This was painted horizontally across the roof, leaving a few broken lines to represent the tiles.

4 Most of the shadows were painted using ultramarine and burnt umber – again, with a touch of orange – using a medium-size brush. These were painted onto dry paper using single brushstrokes and allowed to dry with a hard edge.

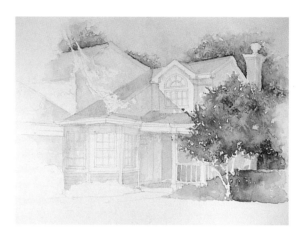

The first stage was to mix the appropriate colours to use as an underwash for the tiled roof and wooden walls. As the entire scene was awash with reds, yellows and oranges, it was essential that these colours formed the basis for the colours of the buildings. The roof was created with burnt sienna, enhanced with a touch of the orange used in the trees. This was painted horizontally with a medium brush to suggest the lines of the tiles, leaving a few broken lines here and there (even a suggestion of individual tiles would have been too much for this enormous roof). This was still only an underwash. The colouring on the lower sections of the walls was created with a watery mixture of the roof colours, toned down with a touch of ultramarine. This was painted onto dry paper.

The sharp, angular features of this building, and the sharpness of the day, meant that the introduction of the main shadow areas had to come next. The shadows cast on the right-hand side of the building were painted once the roof and wall colours had dried, using a mixture of ultramarine, burnt umber, a touch of the orange mixture already used (cadmium yellow and cadmium red – an anchor colour for this painting) and a lot of

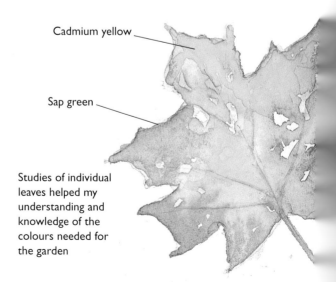

Cadmium yellow

Sap green

Studies of individual leaves helped my understanding and knowledge of the colours needed for the garden

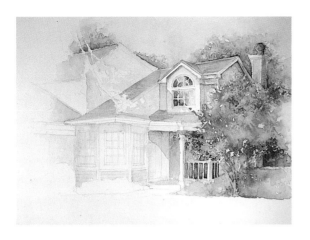

5 The shadows underneath the porch were painted with a small brush using a mixture of burnt umber and ultramarine, and pulled downwards. The same paint and brush were used to paint in between the white wooden fencing, to push the posts out towards the viewer.

6 The windows were painted carefully with a small brush. I worked around the white wooden frames with a mixture of burnt umber, ultramarine and cobalt blue for lightness, with a touch of orange for the reflections.

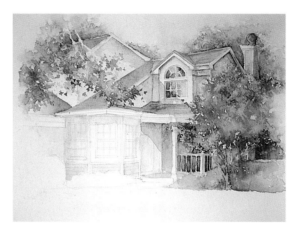

water. The shapes of the shadows were picked out with a single brushstroke and allowed to dry with a hard edge.

Having established the main shadow areas, the next stage was to enhance the shadows underneath the porch. I mixed a deep tone

of burnt umber and ultramarine and painted this directly under the roof of the porch, using a small brush. I pulled this paint downwards onto the dry underwash, and carefully around the bright red leaves of the tree. Seen against a darker background, the leaves appeared considerably brighter. Then, using a small brush and working onto dry paper, I painted the sections between the posts in the same deep tone, creating alternate positive and negative shapes.

Using the small brush again, I carefully painted the dark tones onto the window panel in the top window, leaving the white woodwork untouched. The lighter panels were painted with cobalt blue to lighten the reflections, and, not forgetting the colours of the surrounding garden, a little of the anchor orange was dropped onto a couple of the window panes while they were still damp, picking up the colours that were being reflected from the garden.

LEAF STUDIES

Scarlet lake
Raw sienna
Burnt sienna
Cadmium red

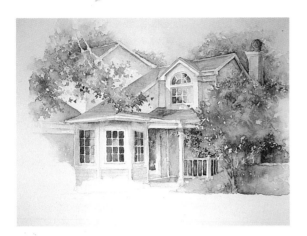

7 Most of the windows were painted using a small brush and a mixture of burnt umber and ultramarine. The shadows underneath the eaves and guttering were also picked out using a small brush, working onto dry paper, with no bleeds required.

The main mass of the building could now be completed by painting in the remaining windows, and adding a few finishing touches to the woodwork and guttering where shadows were cast onto the woodwork. Most of the windows (being lower down the building) reflected mainly the shaded sections of the porch or the lower walls, so did not require any elaborate shading. All that was needed was a strong mixture of burnt umber and ultramarine painted carefully around the window frames with a small brush onto white paper.

As soon as this had all dried, a warm mixture of burnt umber, ultramarine and the orange 'anchor' colour was run along the edge of the guttering using a small brush, and pulled downwards across the white woodwork. I allowed this to dry with a sharp edge. The building itself had now taken on a solid, angular form, bathed in the light which carried the warm, soft orange tones of the surrounding trees. Just a few touches on the right-hand side of the woodwork (the posts and supports) confirmed that no more detail was required on the building.

Completion of the painting depended upon successfully painting the foreground bushes and shrubs as an integral part of the house – one of the human touches that made the house a home. Visually, these features also helped to anchor the house to the foreground.

The shrubs beneath the large window were painted in exactly the same way as the trees but with a slight addition. As soon as the shrubs had dried thoroughly, a dark mixture of sap green and ultramarine was applied, with a small brush, directly underneath some of the warm orange tones; this was allowed to dry untouched.

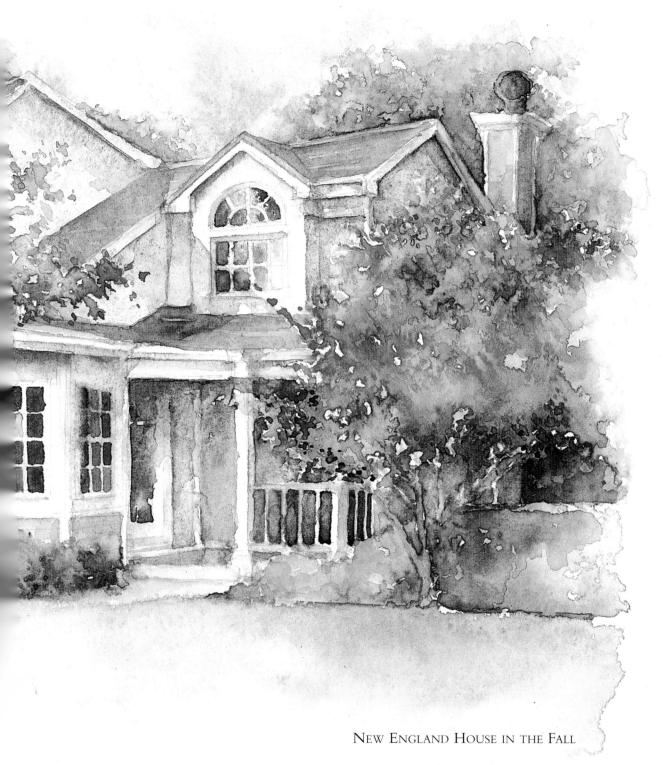

NEW ENGLAND HOUSE IN THE FALL

Because thick paint was put onto dry paper, little movement occurred, and this resulted in the dark green paint drying with a hard line. This suggested that the orange leaves were cascading out over the shadow and towards the path.

The final touch was to apply some orange paint to the grass directly beneath the tree, suggesting that some of the leaves had started to fall. This was done by dropping some orange paint onto the grass (a mixture of sap green and raw sienna) while it was still damp, and allowing the paint to diffuse and bleed.

81

Stucco Buildings

T HIS HOUSE, CONCEALED BEHIND ITS GARDEN WALL, IS A TEMPTATION TO THE WATERCOLOUR ARTIST, NOT ONLY FOR THE INTIMACY OF THE SUBJECT MATTER BUT ALSO FOR THE TEXTURES, COLOUR AND SHAPES TO BE FOUND IN THE WEATHER–WORN STUCCO.

The open windows and the splash of colour created by the flowers in the window boxes give a personal touch to the subject matter

The patchy effect required for painting stucco buildings is best achieved by dropping watery mixtures of paint onto damp paper and allowing it to bleed freely

White stucco buildings require only a hint of colour or toning to suggest ageing or shading. Raw sienna is a good base colour for this

The effect of peeling stucco is best achieved by working with wet paint onto a dry underwash for the exposed stone or brick areas. The wet paint dries with a hard edge around the stucco

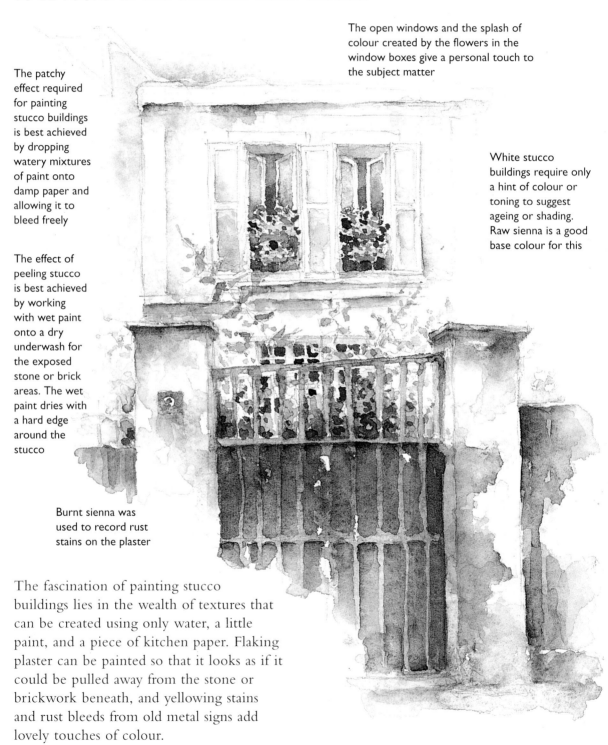

Burnt sienna was used to record rust stains on the plaster

The fascination of painting stucco buildings lies in the wealth of textures that can be created using only water, a little paint, and a piece of kitchen paper. Flaking plaster can be painted so that it looks as if it could be pulled away from the stone or brickwork beneath, and yellowing stains and rust bleeds from old metal signs add lovely touches of colour.

PROJECT: CANALSIDE, VENICE

As tourists or visitors, we tend to forget that the buildings we find so fascinating are very often people's homes. In Venice the canals serve as the roads, and the old buildings have become a labyrinth of apartments.

Having established the line of the buildings and the waterline along the canal, it seemed to me that by far the best starting point was to paint both the sky and the water in one go, as the sky would help to determine the quality of the lighting, and the colours in the canal would be determined by the colours in the sky (although they would by no means be a mirror image). This was freely painted using a large brush and a wash of a mixture of ultramarine and cobalt blue,

working horizontally across the paper for the sky, and vertically for the water, so that the reflections could be picked up later on, as the painting progressed.

The next stage of the initial process was to establish an underwash for the buildings. The pastel shades of the buildings were created by mixing the smallest quantities of paint (mainly cadmium yellow, raw sienna and cobalt blue) with a lot of water and washing this onto dry paper, around the windows, with a medium-size brush. Having established a foundation of colour to work onto, the next stage was to begin to separate the individual buildings by the use of shadows and detail.

I Sky and water were painted with a large brush, using a mix of cobalt blue and ultramarine. The sky was painted using horizontal brushstrokes, the water using vertical brushstrokes.

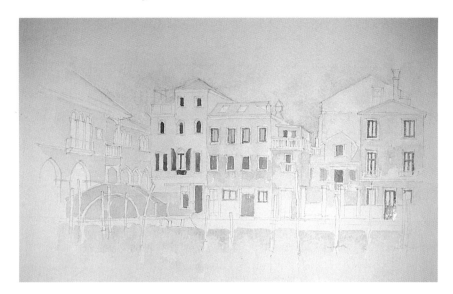

2 The shutters were painted using a small brush. Shadows from the window frames were painted by overlaying the same colour paint (sap green and cobalt blue) and allowed to dry with a hard edge.

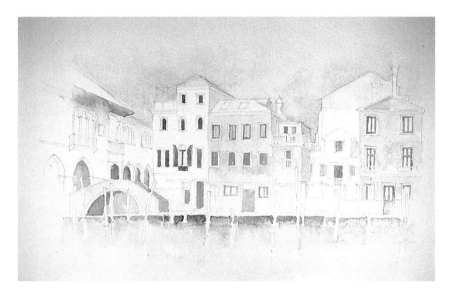

3 Roofs were painted using burnt sienna, working onto dry paper with a medium-size brush and single-stroke applications for each individual roof.

To start making some visual sense of the underwash, the coloured shutters were painted on the windows, giving each building a sense of identity. Even though they were all the same colour (sap green with a touch of cobalt blue), they were all different sizes and shapes and highly individual. They were painted using a small brush and a one-stroke application. As soon as they had dried, the shadows from the window frames were painted by running a line of the same colour paint along the inside edge on one side only using the tip of a small brush, and letting the paint sit and dry exactly where it was placed.

Having worked through a unifying process which ensured that the sky and the water were visually compatible, and that the underwash for all the buildings shared a common set of colours – which were, in turn, visually compatible with the water and the sky (cobalt blue being the anchor colour in this picture) – the buildings themselves could now be painted one at a time, from left to right across the composition.

The main focus now was two-fold: the buildings had to be painted with all their individual eccentricities, and the

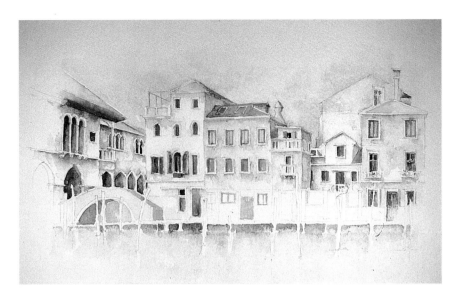

4 Colours and textures on individual buildings were enhanced and strengthened by the addition of raw sienna and burnt sienna, applied with a small brush and allowed to dry with a hard line.

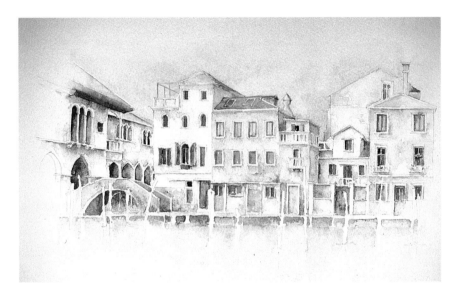

5 Shadows on buildings were applied using a neutral mixture of ultramarine, cobalt blue and a touch of burnt umber to act as a glaze. This added depth to the walls without changing their colour values.

composition also needed to be brought to life through shadows. The method for painting damp stucco and peeling plaster has been dealt with already (see page 82), and was a major feature of many of the buildings. The shading needed a lot of attention.

As the light was coming from my left-hand side, the shadows were falling to the right. So, not only did I have to work with a small brush under the ledges and shutters, but I also had to work with a medium-size brush on the roof tops and on the small sections of the right-hand sides of the

buildings which were visible. These sections were painted using neutral greys (see page 95), mixed from ultramarine, cobalt blue and a touch of burnt umber. As this paint was so thin, it served as little more than a glaze, and the translucency allowed the colour underneath to show through without actually altering the colours that had already been applied. This ensured that a yellow wall only became a darker yellow and a blue wall was only changed to a dark blue wall – and of course, the burnt sienna used for the roof tops only changed to a darker terracotta tone.

While panoramic compositions that look directly at the subject with no perspective can be appealing to paint, an element of perspective, such as the row of buildings on the left-hand side that leads your eye into the centre of the composition, can be very valuable

Compositions will often benefit visually by not being restricted to a rigid rectangular border. Fading out towards the edges can lead the viewer's eye into and across the line of buildings

The final stage of this composition was to paint the reflections from the buildings and the characteristic Venetian poles. This was achieved by collecting the previously used colours in my palette and, using a medium-size brush, pulling them down from underneath the dark colours directly under the jetty, using a single vertical brushstroke for each reflection. As all the reflections were painted in one go, many would run and bleed together – but that is the fortunate reality of painting water with water!

The reflections from these canalside buildings were created by picking up the colours from the bottom of the buildings and pulling them down into the canal area, allowing them to blend and mix

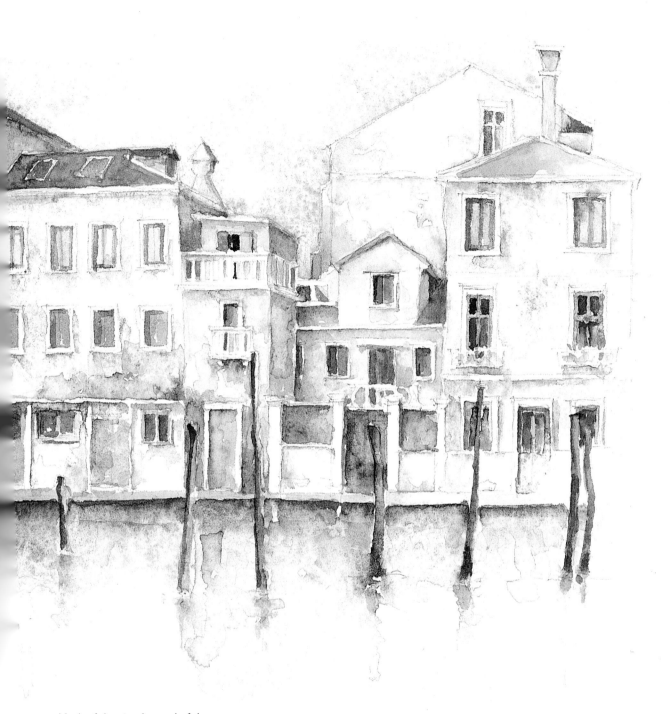

Much of the visual appeal of these
buildings was in the soft pastel tones
that are so characteristic of Italian
stucco buildings

CANALSIDE, VENICE

CHAPTER FIVE

FORMAL
BUILDINGS

*T*he influence of the designers, builders and architects of the
Italian Renaissance has left us a rich legacy in terms of the
*formal buildings that have been built on the streets of towns and
cities in many parts of the world.*

This chapter looks at some of the most architecturally challenging types of building – imposing, prestigious formal buildings, built for posterity. It includes buildings designed in the classical tradition – with features owing much to ancient Greece and Rome, interpreted by the Renaissance architects and refined by later generations. It also includes institutional buildings, such as the universities and colleges that were built in the Gothic tradition, with studies of the elaborate stonework of their façades.

The materials used for these formal buildings are those that will last: stone, stucco and brick. They appear in many guises, depending on the types used (the different types of stone, for instance, which vary in colour from mellow ochres to harsh greys); the effect of light on the subject; and the effect of weathering or pollution.

Although the materials will each require a different approach for recording them, the great advantage is that you only need a very limited range of colours in your palette – a few of the siennas and an ochre or an umber or two are the key colours. The challenge lies in the way in which you mix the colours, and the range of tones that you can achieve. For this I like to use my favourite technique of allowing my colours to mix on the paper rather than in the palette, using a lot of water when mixing paint, and starting with a particularly watery underwash. Before this has had time to dry, I will mix another colour and drop it onto the wet or damp paint previously applied to the paper. The result is that the colours will bleed and blend in parts, but not right across the paper, so they maintain their own identities and qualities on other parts of the paper. I often repeat this procedure three or four times until I have created a vast array of tones out of three or four colours – all by using water, and exploiting the intrinsic qualities of watercolour paints.

Architecture has always been subject to the demands of fashion, and styles and designs spread as rapidly as the worldwide transport system. It is not unusual, therefore, to find formal or classical buildings in most parts of the world, with their fabric in various states of repair or disrepair – all the better for us artists!

Classical Features

T HE CHANGES THAT THE PASSING CENTURIES HAVE
ENFORCED UPON THE FABRIC OF THESE MARVELLOUS
BUILDINGS MAKE THE RIGID DESIGN AND CONSTRUCTION OF
CLASSICAL OR FORMAL PUBLIC BUILDINGS AN INTERESTING
AND CHALLENGING SUBJECT FOR WATERCOLOUR PAINTERS.

The buildings examined here all have one particular design element in common – geometry. The very notion of classical buildings was that they were constructed in line with rigidly defined mathematical and geometrical formulae to give the maximum potential in terms of their aesthetic qualities. They were designed to look good, and as artists we can rarely pass by these wonderful buildings.

The other common factor that these buildings share is the materials from which they are constructed. Because of the desire for authenticity in imitating original classical structures, stone or stucco was used for the majority of the façades, with brick being introduced for buildings constructed within the past two hundred years.

Other elements to look out for are the decorative plasterwork, columns and pillars which were frequently constructed of a contrasting material and, consequently, will be of a different tone or colour. The illustration on the opposite page is a good example of this. It has been designed on the rigid rules of symmetry (although successive generations have made alterations or amendments which have added a curious element of asymmetry), and is constructed of stone with white columns and decorative plasterwork.

Painting these buildings is challenging for two main reasons. Firstly, their structure often requires very careful observation of the shadows created by the pillars, decorations and doorways. Secondly, you will require very few colours indeed. This, however, will require that you use a wide range of tones in your painting to prevent the buildings from looking flat and uninteresting.

SKETCHBOOK STUDY OF FORMAL GATEHOUSE

CLASSICAL FAÇADE

A limited range of colours allows the artist the opportunity to experiment with tones

The grandeur of formal architecture has a faded elegance when the effects of weather and time begin to show

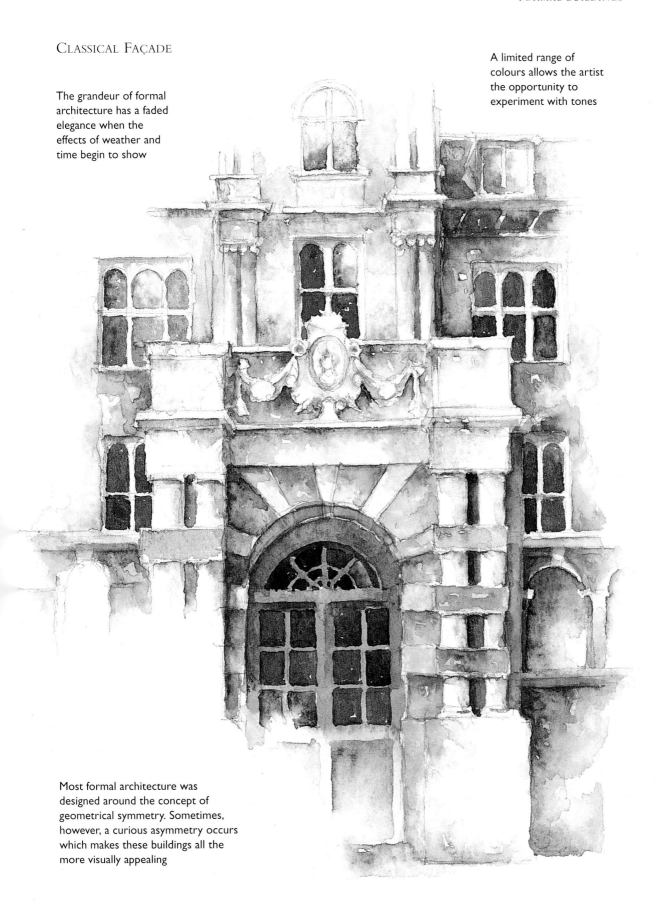

Most formal architecture was designed around the concept of geometrical symmetry. Sometimes, however, a curious asymmetry occurs which makes these buildings all the more visually appealing

Formal Designs

GRAND, CLASSICALLY INSPIRED RESIDENTIAL BUILDINGS CONTAIN A WEALTH OF ARCHITECTURAL DETAILS, PROVIDING AMPLE MATERIAL FOR BOTH SKETCHBOOK STUDIES AND FINISHED PAINTINGS.

Formal town houses similar to the style shown in this painting can be found in towns and cities throughout Britain, America and Australia, built by the wealthy merchant classes of the eighteenth and nineteenth centuries to emulate the styles of the grand houses of Europe.

The geometric design made this building quite simple to record, and this was achieved through a series of studies.

The lower-floor windows were constructed around a circle (see right, for example) and the decorative brick frame followed the line of the semicircle exactly. Having established the structure of the remaining features with a careful pencil drawing, it was then a straightforward exercise to apply a wash of raw sienna, working carefully around the white plaster pillars and decorations using a medium-size brush. This was left to dry without the addition of any other tones – this would come later with the interplay of light and shade created by the addition of shadows. The next stage was to pick out the decorative brickwork around the windows and on the columns. This was achieved by applying a mixture of burnt sienna with a small brush. Because the paint was applied to dry paper it stayed more or less in place.

The next stage was to create some shading within the wall, recording the relief construction of the decorative brickwork and the plaster ledges. These shadows were painted by applying burnt umber, burnt sienna and a touch of ultramarine under these areas. As this was drying, a few drops of

Burnt sienna, burnt umber and ultramarine

Burnt sienna and burnt umber

Burnt sienna

Raw sienna (underwash)

Alcoves and recesses are interesting decorative features in formal buildings and require very dark tones

The brickwork surrounding wooden window frames will often be a different colour or tone from the brick wall

Many doors and windows found in the more formal types of building are designed around geometric shapes such as squares, rectangles and circles

The centre of this window crossbar is the centre of the circle on which the window frame is built

92

Brick Town House

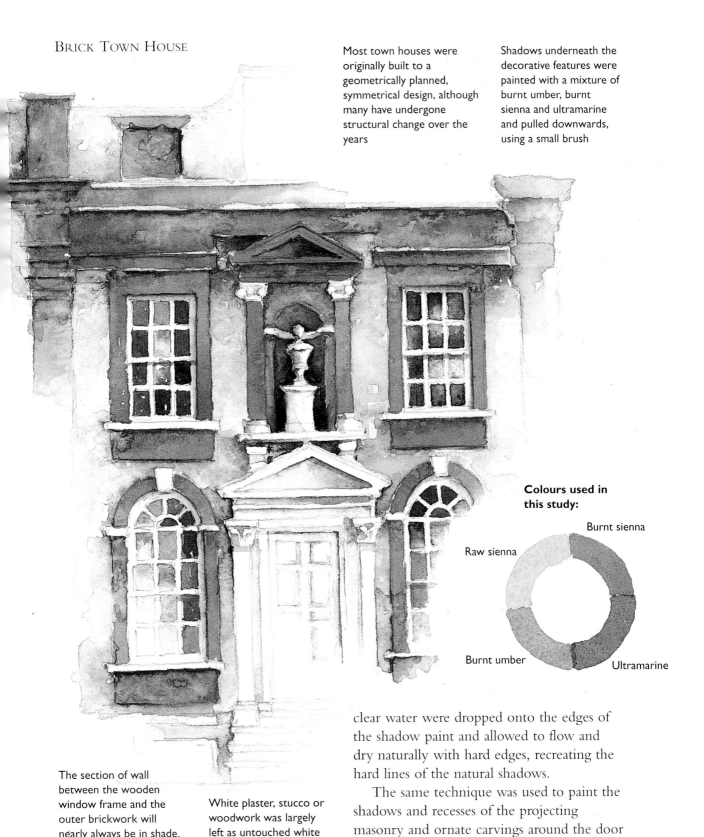

Most town houses were originally built to a geometrically planned, symmetrical design, although many have undergone structural change over the years

Shadows underneath the decorative features were painted with a mixture of burnt umber, burnt sienna and ultramarine and pulled downwards, using a small brush

Colours used in this study:

Raw sienna

Burnt sienna

Burnt umber

Ultramarine

The section of wall between the wooden window frame and the outer brickwork will nearly always be in shade. The colour used here was created by mixing cobalt blue and burnt umber and applying it as a very watery wash

White plaster, stucco or woodwork was largely left as untouched white paper to work for itself. Certain areas were accentuated by the use of shading, but this was highly selective

clear water were dropped onto the edges of the shadow paint and allowed to flow and dry naturally with hard edges, recreating the hard lines of the natural shadows.

The same technique was used to paint the shadows and recesses of the projecting masonry and ornate carvings around the door frame – lines of paint were run directly underneath protruding sections, and pulled downwards using a small brush and some clear water.

Doorways

M OST IMPORTANT BUILDINGS HAVE MAGNIFICENT
DOORWAYS, EITHER TO IMPRESS VISITORS OR TO
SUGGEST TO PASSERS-BY THE STATUS OF THE OWNER.

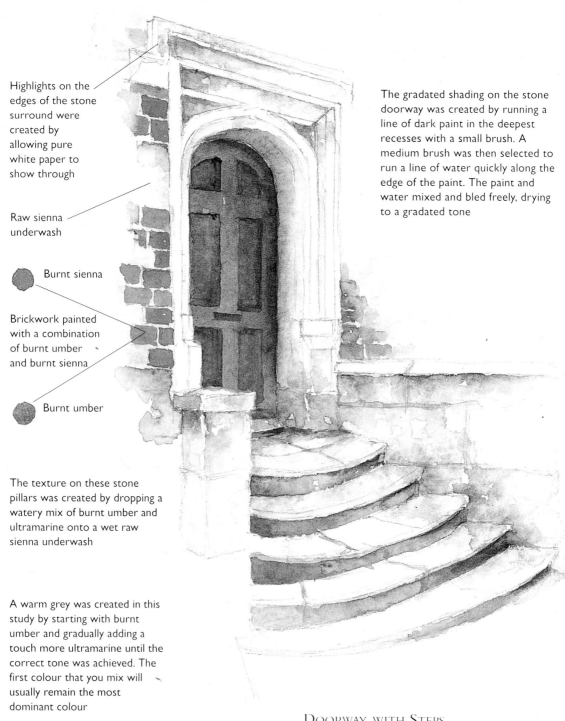

Highlights on the edges of the stone surround were created by allowing pure white paper to show through

Raw sienna underwash

Burnt sienna

Brickwork painted with a combination of burnt umber and burnt sienna

Burnt umber

The gradated shading on the stone doorway was created by running a line of dark paint in the deepest recesses with a small brush. A medium brush was then selected to run a line of water quickly along the edge of the paint. The paint and water mixed and bled freely, drying to a gradated tone

The texture on these stone pillars was created by dropping a watery mix of burnt umber and ultramarine onto a wet raw sienna underwash

A warm grey was created in this study by starting with burnt umber and gradually adding a touch more ultramarine until the correct tone was achieved. The first colour that you mix will usually remain the most dominant colour

DOORWAY WITH STEPS

Black is not needed for shadows. The shaded areas on this white door were all created with combinations of blues and browns

Ultramarine and burnt umber (a warm neutral grey)

Colours that are commonly referred to for their colour temperature value usually mix well. For example, warm ultramarine and the colder cobalt blue work particularly well together here

Ultramarine and cobalt blue mixed together enhance the shadows without adding too much depth of tone (a more subtle blend than the mix with burnt umber)

Watery wash of cobalt blue

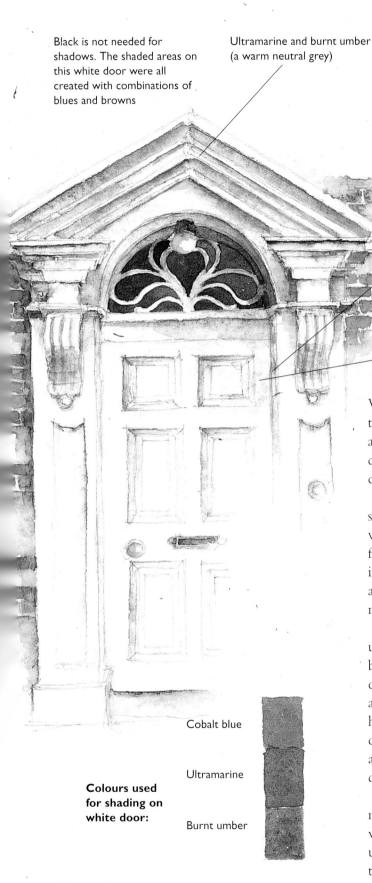

Cobalt blue

Ultramarine

Colours used for shading on white door:

Burnt umber

WHITE DOOR

While the decorative plaster surround and the wooden door in this study were actually painted white, very little of the door was left white by the time I had completed the sketch.

Unless you are faced with glaring sun shining directly onto a white object, you will usually find that to record white features such as doors in watercolour will involve treating much of your subject to an extremely thin and watery wash of a neutral grey.

Warm greys can be mixed using ultramarine (or ultramarine violet) and burnt umber in small quantities, whereas cold greys can be mixed with cobalt blue and burnt umber. A neutral grey, however, could be created by mixing cobalt blue and ultramarine, and then just a touch of burnt umber to give some depth to the tones.

This mixture will be diluted even more when washed onto the door with a wet brush and then pulled around a little using clear water, creating a highly translucent paint which tints rather than covers whatever is beneath it.

Arches

THE GRACEFUL ELEGANCE OF THE GEOMETRICALLY DESIGNED ARCH IS BOTH TECHNICALLY AND AESTHETICALLY REWARDING TO RECORD IN PENCIL AND WATERCOLOUR, AND EXAMPLES ARE OFTEN TO BE FOUND IN THE MOST PEACEFUL SETTINGS.

The intricate tracery and carving found in churches, cathedrals, cloisters and colleges is highly demanding in terms of the level of observation required to get a row or series of them accurate – for this reason I always set about making relevant sketchbook studies before using them in a composition.

As I have already mentioned, geometry is a common design factor in important public buildings. Ecclesiastical buildings, from the largest cathedral to the smallest rural church or college chapel, demonstrate this, even in their smallest details. The arch study shown on this page was constructed around a framework of three circles – even the circular opening of the window has an inner tracery which is based on a design with three circles.

Having drawn or sketched the construction lines and developed the smooth curves of the arches in pencil, you may well find that the painting that follows will appear as almost a monochrome exercise. Where the stone arches or windows have been the subject of partial renovation, the different colour of the new stone is usually noticeable. Most stone is a very dull colour, but contains many different tones. This is particularly evident in the outer edges of stone arches and in the tracery, as the different levels of stone worked by the craftsmen create the different layers of light and shade.

The edges of the stone ridges in this particular study were picked out using a small brush, and painted onto a previously applied underwash of raw sienna. To maintain a level of neutrality in the colouring, some cobalt blue was mixed with a little burnt umber.

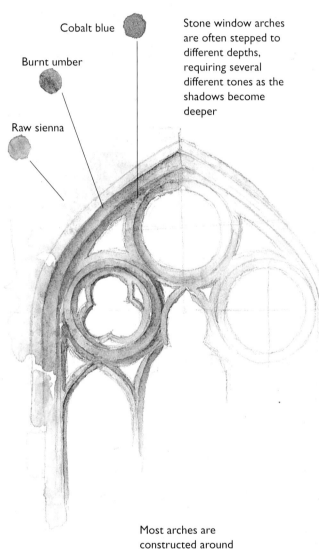

Cobalt blue

Burnt umber

Raw sienna

Stone window arches are often stepped to different depths, requiring several different tones as the shadows become deeper

Most arches are constructed around the geometry of the circle. This pointed arch also has a typical arrangement of three circular openings in its stonework tracery

ARCH STUDY

ARCHES ON A BRIDGE

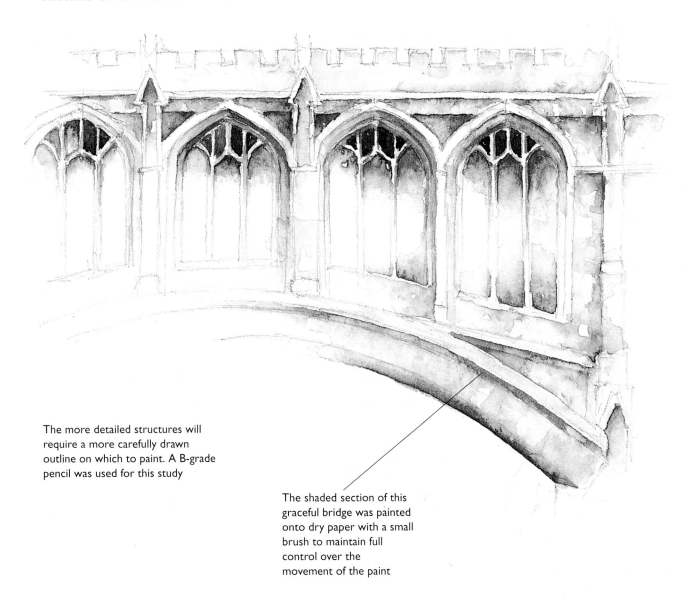

The more detailed structures will require a more carefully drawn outline on which to paint. A B-grade pencil was used for this study

The shaded section of this graceful bridge was painted onto dry paper with a small brush to maintain full control over the movement of the paint

While this combination will result in a cool grey if washed directly onto white paper (as was mentioned on the previous page), when it is washed over the top of a raw sienna undercoat, it absorbs a little of that colour's warmth, and takes on a more neutral tone.

Using a small brush, this mixture of cobalt blue and burnt umber was run along the outer edge of the first indent in the arch, starting at the top and pulling the paint in a gentle sweep along the underside of the stone ridge. As this was drying, a very careful painterly manoeuvre was being planned.

Using the very tip of the small wet brush, I partially pulled some of the recently applied paint downwards onto the next inner ridge, though making sure that the paint directly under the outer ridge was left untouched. I wanted this to dry with a hard line, emphasising the line of the carving and the hardness of the stone. This procedure was repeated again with the inner stone of the arch. Each successive layer resulted in a darker tone, giving the impression that the arch on the paper really did have a three-dimensional element to it.

Symmetry

THE SYMMETRY OF ARCHITECTURE IS APPEALING TO ALL OF US WITH A FEELING FOR DESIGN, BUT WHEN THE BUILDING MATERIALS ARE AFFECTED BY THE UNPREDICTABLE EFFECT OF WEATHERING, A DEGREE OF ASYMMETRY IS INTRODUCED, WHICH GIVES ADDITIONAL INTEREST.

Burnt sienna

Burnt umber

Ultramarine

Raw sienna

The decorative details and carvings were treated to a light underwash. When this had fully dried, a deep colour (ultramarine and burnt umber) was painted behind them using a small brush

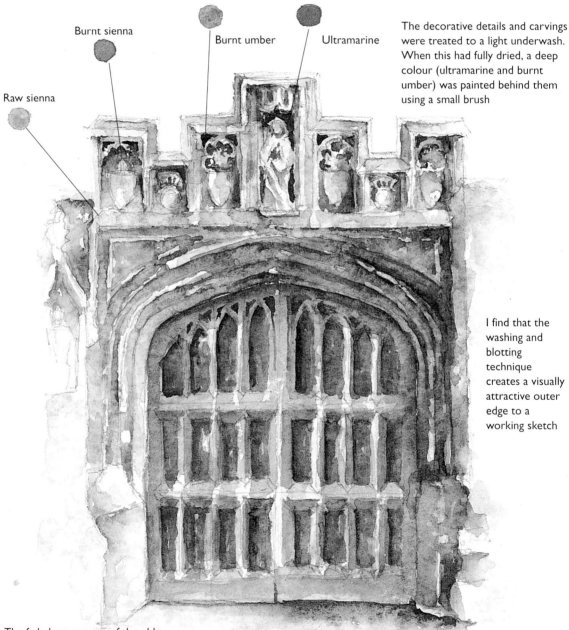

I find that the washing and blotting technique creates a visually attractive outer edge to a working sketch

The faded appearance of the old wooden door was created by applying a wash of burnt umber and cobalt blue directly onto white paper (without an underwash). The paint dried to an appropriately washed-out look

OXFORD COLLEGE GATEWAY

The warmth of the old stone was created by applying a raw sienna underwash and making sure that all subsequent colours were mixed with a burnt umber base

PROJECT: CLASSICAL FRONTAGE

1 An underwash of raw sienna was washed freely across the line drawing using a large brush, and left to dry with little intervention.

2 Burnt sienna and raw sienna were mixed together to create the terracotta stone colours and painted on top of dry paint. Clear water was then dropped onto the drying paint to create textures.

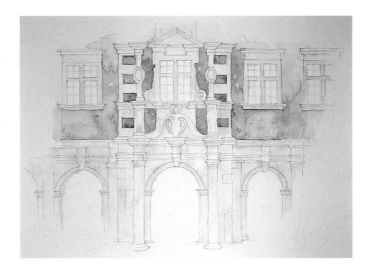

The pure symmetry of this elaborate façade was the first thing to catch my eye. Only later did I appreciate the full range of warm sienna tones that the stonework held.

Having drawn the main lines of symmetry running both vertically and horizontally across the paper, and then completed the curves of the arches, a very free wash of raw sienna was applied rapidly across the line drawing with a large brush, leaving only the spaces between the arches blank. (I had already decided that they would be left blank to avoid any visual overload. The intricacies of the stonework and its rich colours were more than adequate.) This was left to dry, as the next stage required a level of control.

Using a medium-size brush, the next application was painted onto the upper section of the building. A mixture of burnt sienna and raw sienna was mixed to record the almost terracotta tones of the warm sun-baked stone. Again, this was painted in a very free manner to prevent it drying with a smooth finish. In fact, just to make certain that little of the paint dried evenly, a few drops of clear water were dripped onto the damp paint and allowed to bleed and dry without blotting. This created the hard lines caused by patchy plaster and the effects of damp on a stone wall. This was then allowed to dry before the next stage of establishing the shadows was attempted.

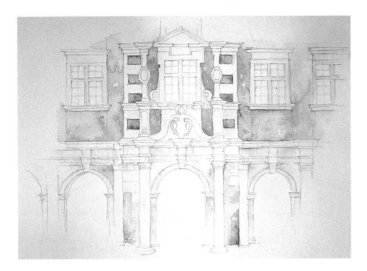

Large, complex buildings will require you to make some decisions about how much you include in your composition. It will rarely be practical to paint the entire site. For this reason I chose to fade the paint out at the edges

3 A small brush was used to apply burnt umber and ultramarine to damp sections of stone, with burnt sienna dropped on top of the bleeding paints.

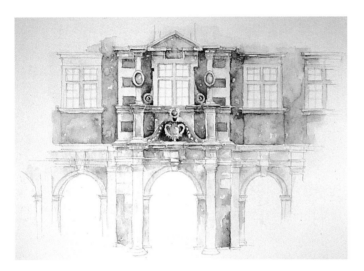

4 Burnt umber and ultramarine were painted underneath ledges and decorations using a small brush, and pulled downwards using clear water.

One of the major visual factors that suggests age on a building is rising damp. I therefore decided to start at the bottom and paint my way towards the top.

The first application of paint was a mixture of burnt umber and ultramarine, which was applied to the very base of the wall and pulled upwards, using a small brush. To counteract the hard edges that would have been created had this wash been allowed to

dry, I dropped a little burnt sienna at the very top of the wash, and this bled downwards, creating the impression of exposed brick. The same principle was used on both sides of the central arch – a succession of washes and clear water dropped on top of each other and allowed to bleed and find their own direction. While the structure was symmetrical, the tones and colours did not follow this predetermined pattern.

FORMAL GATEHOUSE

The windows reflected the sky and the colours of the day. They were painted with a mixture of cobalt blue and ultramarine, with a touch of burnt umber to deepen the tone

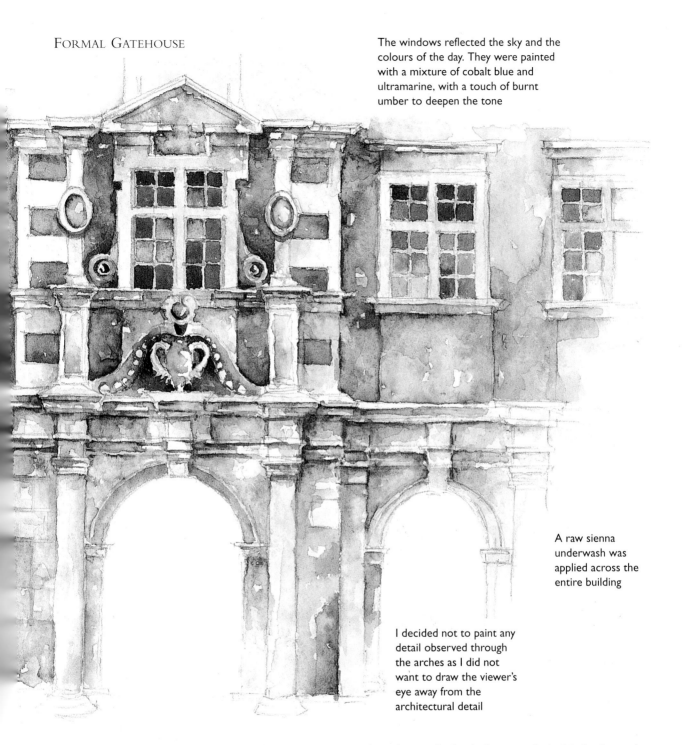

A raw sienna underwash was applied across the entire building

I decided not to paint any detail observed through the arches as I did not want to draw the viewer's eye away from the architectural detail

Having established the tones and textures on the lower part of the building, some serious work had to be put into the shading on the upper section. As I had already begun the process of creating the textured finish to the wall, the shading would be relatively simple. A small brush was used to run a dark mixture of burnt umber and ultramarine around the edges of the plaster decoration and underneath the ledges. Before this had time to dry, the same brush was used to pull the colour downwards, dropping a little clear water around the edges to soften them for the final touch.

The windows were painted using assorted combinations of cobalt blue, ultramarine and burnt umber to complete the painting of this stone façade.

101

STREET LIFE

T owns, cities and villages provide architectural subjects for painters that offer variety and interest, but it is often the introduction of the human element that will bring the whole scene alive.

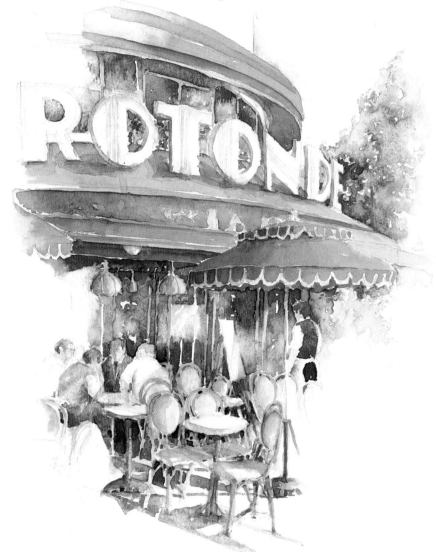

This chapter brings together the buildings in towns and cities with what actually happens outside them, on the streets – the scenes of human activity that are played out every day on the sidewalks creating the excitement that exists in a built environment.

I also consider some of the other evidence of human life around buildings – street signs, café signs, market stalls and barrows – all of

the bits and pieces that are a vital part of the town or city scene. If we can see these objects when we are looking at certain buildings, we must consider carefully not whether we should include them, but why we should think of leaving them out!

There are some new considerations that apply to the subjects in this chapter. Perching on a draughty street corner to sketch a market stall with a constant tide of moving people and the inevitable smells and noise of road traffic is a very different situation from sitting in the spiritual solitude of a Tuscan hilltop cloister and painting in shade and comfort, or even sitting on the seashore and sketching the fishermen's sheds as seagulls screech and swoop above the lapping waves. I will, therefore, offer some words of advice regarding the practicalities of painting street life.

Firstly, it is usually a good idea to choose a subject that is unlikely to have any visual obstructions – such as large vans or cars – stopping in front of it. Paved or pedestrianised areas are always a good place to start, from this point of view.

Secondly, you will probably only ever develop a series of sketches under the conditions that you will encounter on the streets of towns and cities, so why not content yourself with a series of visual notes to help you to develop a picture at a later date? A few line sketches, a few colour studies, a few written notes notes, and perhaps a photograph (after all, a camera is simply a visual tool) can be quite enough to take away and then develop into a full-scale composition in the comfort of your own home.

Finally, you will often be wanting to sketch or paint people while they are simply sitting or standing about, or going about their work. Quite reasonably, some may not be happy to be constantly stared at, thinking that they are having some sort of notes being made about them. I personally believe that it is safer to be direct from the beginning. Approach the people if possible, introduce yourself, and tell them exactly what you wish to do. This will usually produce a much more favourable response than trying to be furtive, and failing.

City Steps

S OMETIMES EVEN THE MOST FASCINATING LATTICE OF LIGHT
AND SHADE CAST ACROSS OLD COBBLED STONES BY THE
FIRST LIGHT OF SPRING IS NOT ENOUGH TO MAKE A PAINTING
INTERESTING, AND IT NEEDS PEOPLE
WALKING IN AND OUT OF IT.

Often, people become such an integral part
of the built environment that it would be
hard to imagine how it would look without
them. However pleasant the view at the top
of these steps, I could have found little to
paint without the constant but ever-changing
flow of people walking up and down them.

When considering how to paint figures
and buildings together remember that figures
are bound by the same set of perspective
rules as buildings. The further they are away
from you, the smaller they will appear – the
nearer they are to you, the larger they will
appear. This is illustrated here. As you look
along the line of the steps, the railings, lamp
posts and steps appear to become smaller –
equally, the figures have been made
correspondingly smaller, giving the feeling of
movement and scale.

Secondly, most people going about their
daily business tend to wear muted colours –
light and dark blues are by far the most usual
colours chosen for clothing, followed by light
browns and soft beiges. Occasionally you will
spot a red or yellow jacket or shirt in a crowd
– these are important as they help to break
up the dull uniformity – but generally, figures
on a street will blend together well.

The final point to consider here is tone.
Just as a row of buildings will appear to
become lighter as you look towards the far
end (see pages 71–73), so figures in the
furthest distance will appear to be a lighter
tone. Remember, not only will you have to
draw them a smaller size, but you will need
to use a more diluted mix of paint than you
might use for those in the foreground.

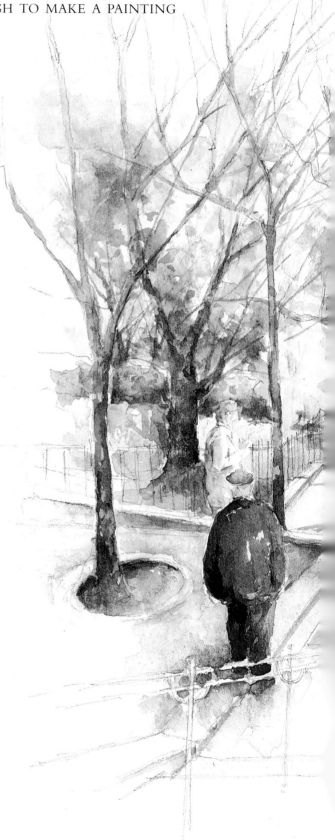

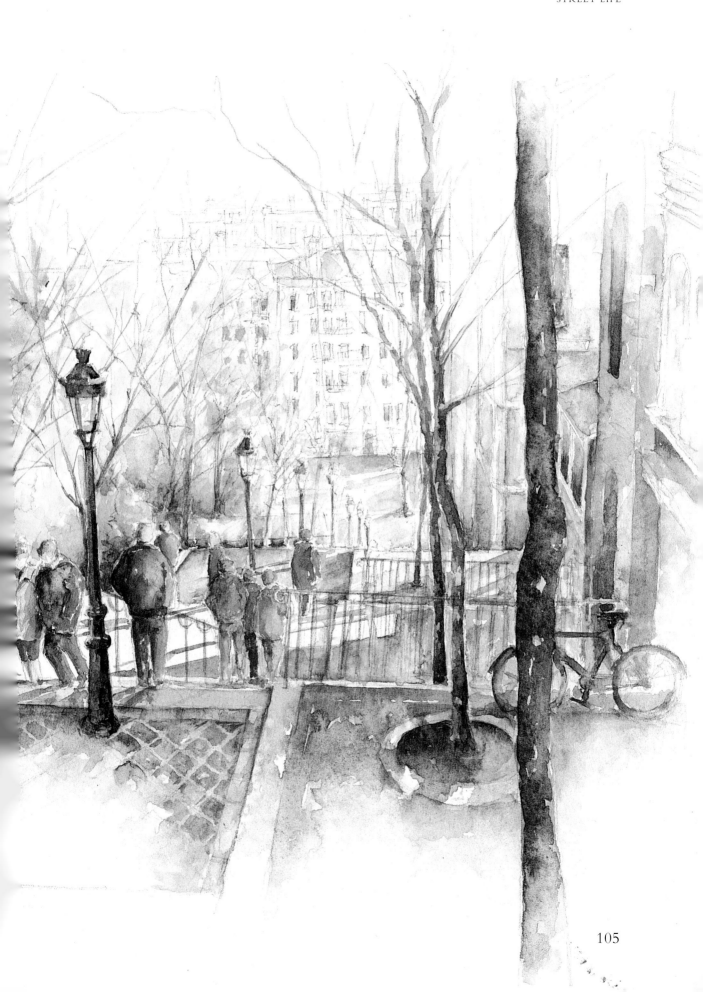

Markets

Temporary structures, such as street market stalls, inject a vitality into towns and cities. With them comes a bustle of people and a burst of colour that adds an extra dimension to a painting of a street scene for the artist.

I find markets – and particularly street markets – fascinating places: the noises and colours all appeal to me greatly. In these markets you will find a sudden burst of intense colour as the stalls, the stall-holders (often colourful characters themselves) and their produce invade what is often otherwise a dull environment.

The painting of the flower stall in the City of London had these qualities and proved to be an irresistible subject. The first thing that caught my eye was the marked contrast between the gloomy tones of the old stone City buildings, and the temporary invasion of bright colour in the reds of the awning, set off by the profusion of colour of the flowers on display.

The colours mixed for the background buildings will be familiar to you by now – raw sienna, burnt umber and cobalt blue. However, the reds and yellows that you will often find in commercial environments such as shopping districts and markets do warrant some consideration.

Cadmium red was used for the awning of both the market stall and the shops immediately behind it. Cadmium red is a deceptive colour – it looks very rich and strong when wet or in the tube or pan, but if applied directly to dry white paper, it will quickly dry to a disappointing pink, losing the intensity of colour that it previously exuded. This characteristic can be seen in the red stripes of the stall awning, which were painted using cadmium red directly onto white paper. To counteract this, and to

Markets, street fairs and bazaars are wonderful events and places to paint. Usually set against a backdrop of buildings, they attract a constantly changing population

Cars, vans and trucks can sometimes help to give a sense of scale to your picture, often connecting the background with the foreground

produce a red of body and substance, an underwash is required. The shop awnings, the bright red of the barrow itself, and many of the flowers, had an underwash of cadmium red mixed with cadmium yellow (alternatively you can buy a tube or pan of ready-made cadmium orange), applied thinly and allowed to dry. This colour gives the highly translucent cadmium red a good base colour, enhancing its qualities and allowing it to glow, providing a good colour whenever required. Cadmium yellow, on the other hand, tends to stand on its own, rarely needing an underwash as long as it is applied without too much dilution with water.

Again, the figures in this painting are essential to the composition – the buildings and the flower stall simply would not be there if it were not for the people. To create more of a snapshot image, and to give the scene a slightly more animated feel, I made sure that at least one of the figures was walking either into – or out of – the scene. This device helps to prevent figures from looking like waxworks temporarily taken from a museum and planted in the street!

LONDON STREET SCENE

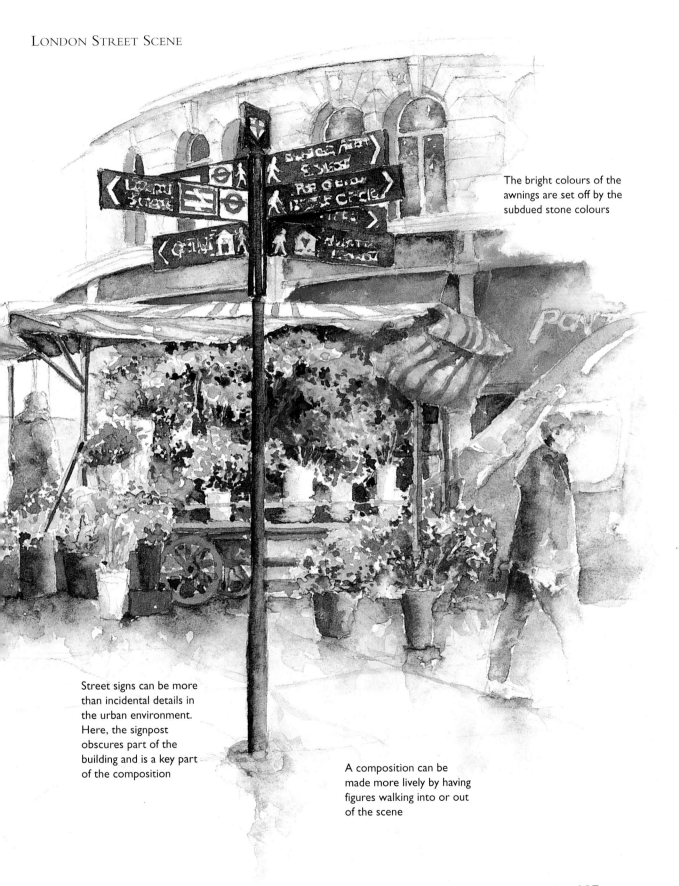

The bright colours of the awnings are set off by the subdued stone colours

Street signs can be more than incidental details in the urban environment. Here, the signpost obscures part of the building and is a key part of the composition

A composition can be made more lively by having figures walking into or out of the scene

PLACE DU TERTRE, MONTMARTRE, PARIS

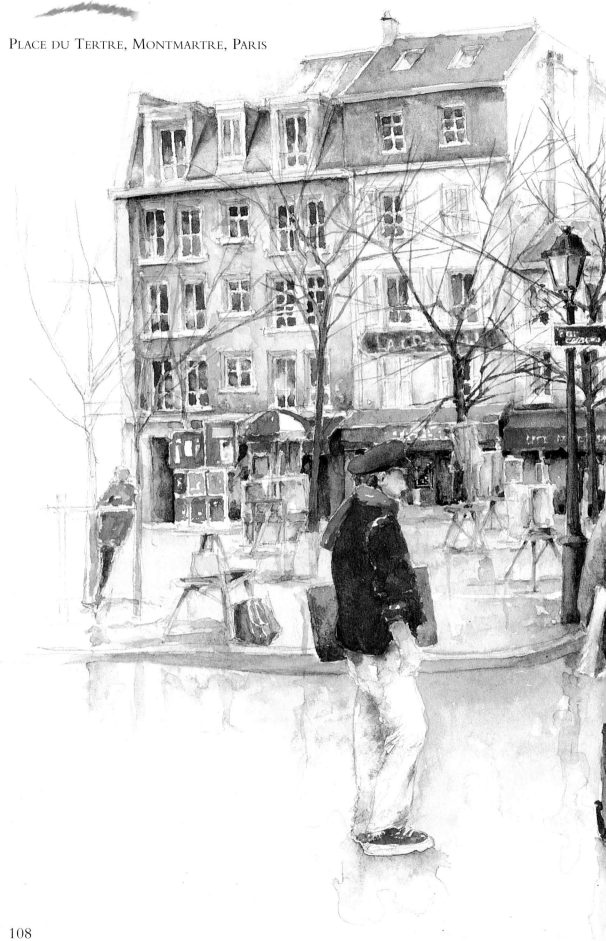

Some street scenes are best painted when the weather conditions are not so good. In the height of summer, artists congregate in this remarkable square in Montmartre. Yet, while it is attractive in this season, the buildings are fully obscured by the huge trees and heaving mass of tourists.

For this painting I chose not only the season, but also the day, with care. Painting on a wet April morning meant that the branches of the trees would be bare, and the square would not be too busy, allowing me to see its key features. It also gave me the opportunity to use a technique that I thoroughly enjoy – pulling watery paint in downward strokes to create reflections on shiny streets and pavements. This can be a particularly useful effect for subjects where the immediate foreground does not have any specific features to record.

109

People and Buildings

ALTHOUGH NOT ESSENTIAL, IT IS INTERESTING TO CONSIDER HOW FIGURES RELATE TO THE BUILDINGS THEY INHABIT, OR VISIT, OR WORK IN AND AROUND. ON THE WHOLE, FIGURES TEND TO HAVE SOME RELATIONSHIP WITH ONE ANOTHER IF THEY ARE IN THE SAME SCENE, WHETHER THEY ARE TALKING TO ONE ANOTHER, OR SIMPLY PARTICIPATING IN THE SAME ACTIVITY. IN OUR CAPACITY AS ARTISTS, THEY ARE ALWAYS WORTHY OF OUR CONSIDERATION.

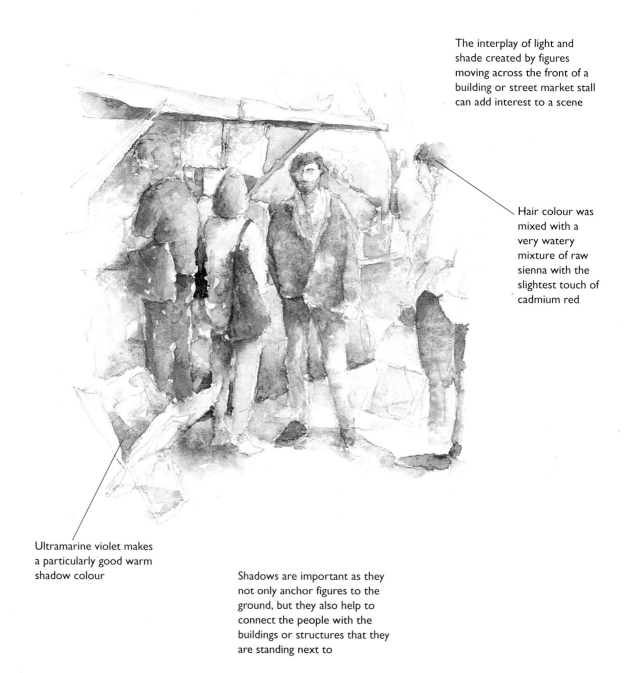

The interplay of light and shade created by figures moving across the front of a building or street market stall can add interest to a scene

Hair colour was mixed with a very watery mixture of raw sienna with the slightest touch of cadmium red

Ultramarine violet makes a particularly good warm shadow colour

Shadows are important as they not only anchor figures to the ground, but they also help to connect the people with the buildings or structures that they are standing next to

PROJECT: INDOOR MARKET STALLS

The first stage with this composition was to produce a reasonably detailed drawing incorporating the buildings, architectural facets, market stalls and figures, ensuring that the rules of perspective as considered on page 104 were followed, with the figures and structures decreasing in proportion towards the distance.

Once the initial drawing was complete, the first stage was to put an underwash onto the buildings. As usual, no consideration was given at this stage to tonal values or light and shade – just a layer of raw sienna onto which the textures and shadows in the subject would eventually be painted.

As this initial underwash was drying, a small brush was used to apply an underwash to the remaining fabric of the building. A watery cobalt blue was used for the paintwork on the wrought-ironwork supporting the roof, and cadmium red and sap green for the coloured woodwork of the shop fronts. This completed the underwash stage for the fabric of the buildings against which the hustle and bustle of the market would be recorded.

1 A flat underwash of raw sienna was applied with a medium-size brush to the brick areas of the building and allowed to dry, with no attempt at shading.

2 The remainder of the built structures were painted in their appropriate colours (cobalt blue, sap green and cadmium red) with a small brush, creating a background against which the rest of the picture could be painted.

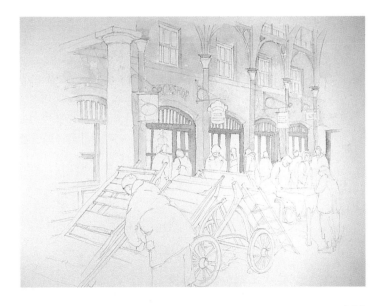

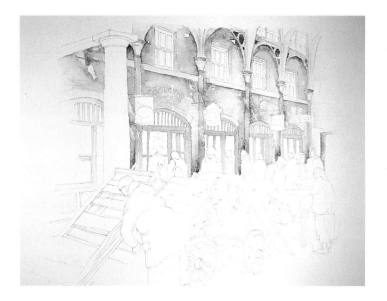

3 The gaps in the ironwork were painted with a small brush, using cobalt blue, burnt umber and raw sienna, and left to dry. A medium brush was used to apply the same mixture underneath any ledges, and then pulled downwards using clear water to create shadows and textures.

4 The deeper tones of the door- and window-frame colours were mixed and applied using a small brush. The bottom edges of the frames were painted with the tip of the small brush and a touch of ultramarine.

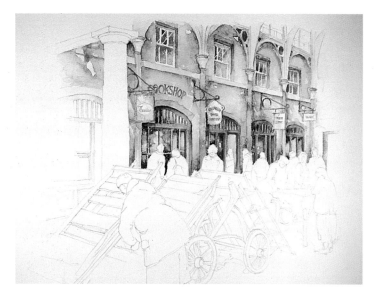

The next two stages involved creating shadows and textures, building on the underwash already created.

The first area to be developed was the section of the wall directly underneath the wrought-ironwork. Using a small brush, I painted a mixture of cobalt blue, burnt umber and raw sienna in between the gaps in the ironwork. With a medium brush, a line of the same paint mixture was run directly underneath the ironwork and pulled downwards, using a little clear water. This process was continued behind and around all the ridges and ledges.

Stronger, less diluted mixtures of the same colours used for the brightly painted wooden window and door frames were prepared next. Again, these were applied using a small brush. The area directly underneath the frames needed to be darkened a little as no light was coming up from the ground. Using the tip of my small brush, I added a touch of ultramarine to both the red and the green and, taking great care, painted the undersides of the frames, placing a shadow in the correct place to enhance the three-dimensional feel that was now developing.

The final stage here was to complete the windows and doors by painting the glass. As the windows were not directly reflecting

outdoor light, a higher proportion of burnt umber was included in the usual window mixture of ultramarine and cobalt blue. Then, using a small brush again, this was carefully painted around the reflections and the signs and stickers that appear so frequently in shop frontages.

The next stage in this composition involved establishing an underwash on which to develop the people. The figures in the far background were the first to be painted.

Since little (if any) detail was required at this stage, I used a medium brush to apply loosely an underwash of cobalt blue and burnt umber to the cluster of people on the far right of the picture. This represented most of the colours of their visible clothing, and when dry, would be used to represent the lightest of tones – areas such as shoulders, arms and bags that would be likely to catch the light and maybe reflect a little of it. I left this to dry. The next stage was to paint in a few shadows under the arms, underneath jackets, behind bags and so on, to make the light sections stand out, and give some definition to the figures in the process. This was done using the tip of a small brush, and with only a dab or two of colour.

Having completed the background figures, it was then the turn of those moving

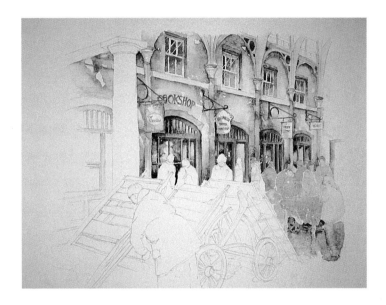

5 Background figures were painted using a medium brush to apply an underwash of cobalt blue and burnt umber. Colours were applied separately and allowed to bleed. Details were picked out with a small brush working onto dry paint to create shadows.

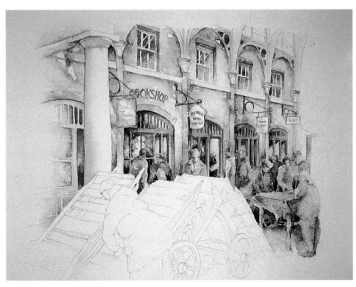

6 Skin tones on the middle-ground figures were painted using a small brush and an extremely watery mixture of raw sienna with the slightest touch of cadmium red. Shadows were created using cobalt blue.

113

in or out of the middle ground. Exactly the same technique was used in painting most of the figures. However, as they were closer, more of them could be seen, and both the skin and hair colours had to be considered. My basic skin colour is mixed with the slightest imaginable touch of raw sienna and even less cadmium red – and a lot of water. This colour is more of a tint, and, using a small brush, I applied it as a single wash and allowed it to dry. The hair was then painted using a combination of burnt umber, raw sienna and cobalt blue – again, as tints. The shadows were then added under the chins and around the collars by picking out the shadow shapes with a small brush and a hint of cobalt blue – the translucent qualities of the paint ensured that the skin colour remained constant, only the tone varied.

The final stages of this composition involved applying an underwash to the visual clutter in the foreground and then moving on to paint the shadows and darkest stones with a small brush, which had the effect of pushing the lighter tones forward.

As usual, the underwash colours were applied loosely with a medium brush, and allowed to dry. Having completed this, the shadows in between the handles of the cart and the struts and planks, and the areas between the spokes of the cartwheels, were picked out using a small brush. The depth of tone varied considerably, ranging from the deepest tones at the top of the triangular shape created by the carts, to the lighter shadows with clearly discernible shapes on the ground. Only two colours were used, but a wealth of tones was created. Ultramarine and burnt umber give the deepest, darkest tones, and these were painted in the dark areas at the top of the cart shapes. The mixture was gradually diluted for the lighter tones in the lower part of the foreground. It was only when the shadows had been established that the brighter colours of the red and green carts were applied, using cadmium red and sap green respectively.

This picture was completed by painting the larger-than-life figure in the foreground using the same technique as previously described, only picking out a few more folds and creases in the clothing for shading.

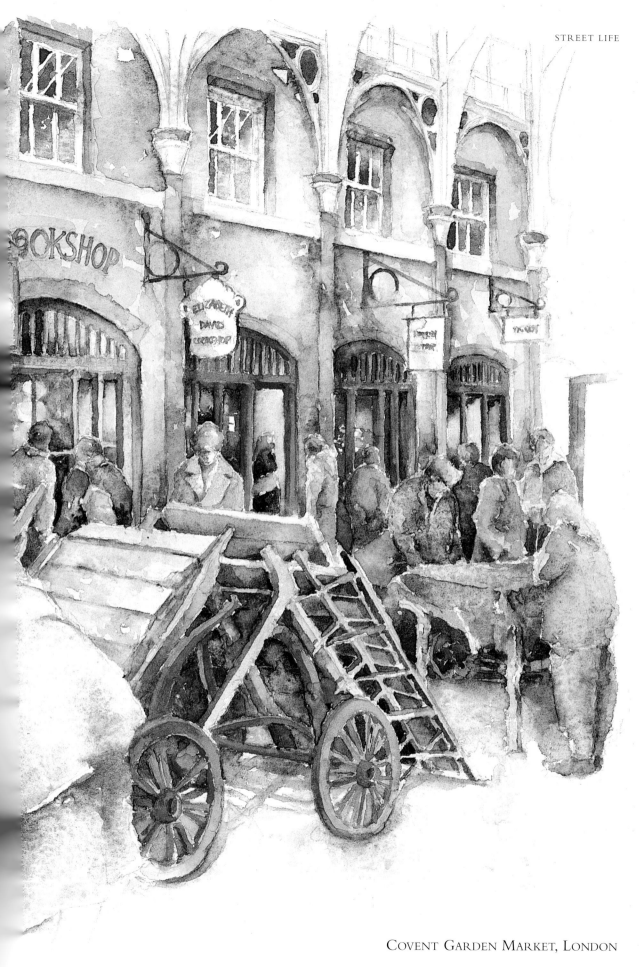

COVENT GARDEN MARKET, LONDON

Café Tables

I̲T IS NOT JUST PEOPLE THAT YOU CAN PAINT FROM CAFÉ TABLES —
SIGNS AND MENUS ARE JUST AS MUCH AN INTEGRAL PART OF THE
CAFÉ ENVIRONMENT, AND THEY CAN MAKE INTERESTING STUDIES,
OR SUBJECTS FOR A PAINTING.

The effect of flaking plaster was created by running a very fine line of ultramarine directly underneath the coloured edge using the tip of a small brush. This will dry, creating a shadow

Scratches on the drainpipe were created by allowing thin, vertical stripes of white paper to show through

Some of the patchy appearance of the plaster was created by dropping clear water onto damp paint and allowing it to dry with a hard edge

The marked contrasts of the red and green were the initial attraction of this study

FLAKING CAFÉ WALL

Sitting at a café table can be a visually rewarding experience. You will usually be able to witness people going about their daily business on the streets against the backdrop of a vibrant town or city. You will probably be surrounded by subjects as they sit at the café tables – just within sketching distance. Then there is the café building itself, complete with signs attached to walls and any other architectural features with which it might be adorned.

The sketchbook study of a café detail on this page is of a wall that clearly shows signs of neglect. But for me that was its particular charm: the flaking plaster and the strong contrast between the red and the green paint made this small item of urban decay come alive for me.

116

PROJECT: PARISIAN CAFÉ

Arguably, there is nowhere else in the world to compare with Paris when it comes to simply sitting, drinking and watching the world pass by – especially at a café as famous as La Rotonde. In fact, to be honest, I felt quite intimidated sitting at seats where artists such as Modigliani and Picasso had sat and sketched, and where writers as diverse as Hemingway and Louis Aragon had sat and made their own 'literary sketches'.

Having overcome these feelings, I began my work with a line drawing that included all the information in my line of vision – the important identifying signs, the large round umbrella, the group of figures sitting and conversing, and a waiter walking into the composition on the far right.

As the late spring day was awash with colour and light, the first stage was to paint in the sky and the fresh greens in the background trees. This would enable the bright reds of the café terrace to stand out even more when they came to be painted.

A thin wash of cobalt blue was painted onto the sky area using a medium brush and a series of smooth horizontal strokes – the sky was cloudless so this was important. As soon as this had dried, a little of the cobalt blue was mixed together with sap green and a little cadmium yellow. This mix was painted onto the trees with a medium-size brush. While this paint was still wet, ultramarine was added to the same mixture to darken it, and dropped on to represent the shadows in the trees. This was allowed to dry by itself. The lush, vibrant green now provided an excellent backdrop against which to paint the foreground.

The next two stages involved developing the top section of the café with its bright red frontage and distinctive sign. As a lot of red was required, I first created an underwash with cadmium red (the qualities of this colour were considered on page 112). As the red awning had been subjected to many years of direct sunlight, it was a little faded in

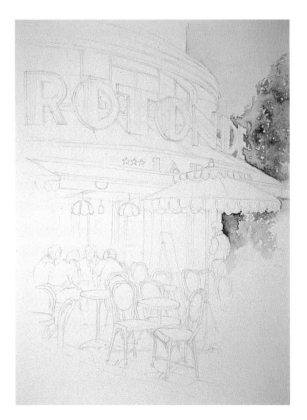

I The sky was painted with cobalt blue, using a medium brush and even brushstrokes. The trees were painted using the same brush and sap green plus cobalt blue and a little cadmium yellow: ultramarine was added for shadows in the trees.

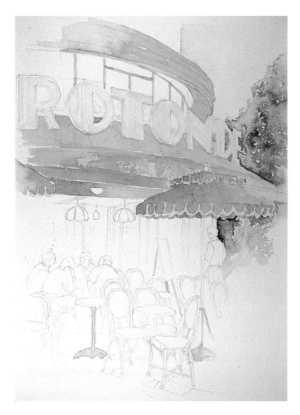

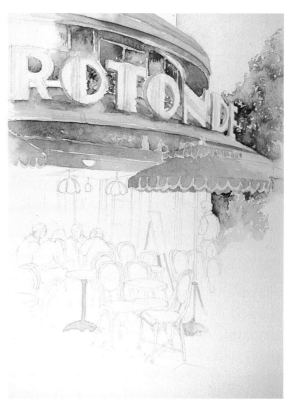

2 An underwash of pure cadmium red was applied to the top section using a medium brush, and raw sienna was applied to the lettering using the same brush.

3 Reflections on the windows were created by painting panes with ultramarine, cobalt blue and a touch of burnt sienna. Water was quickly dropped into the centre, and cadmium red was added to the top and raw sienna to the bottom of the panes, acting as reflections of the surrounding colours.

parts. For this reason, using a medium brush, I applied a direct wash of pure cadmium red to all of the appropriate areas, working carefully around the letters. This dried to a very pale, insipid red, but it would make a good underwash for the following applications. The letters were treated to a watery underwash of raw sienna applied with a medium brush.

As soon as this stage had dried, the top section of the café could be brought alive by the addition of the reflection from the windows and the shadows on the awning. Another light wash of cadmium red was added to the top area, leaving a few light patches for highlights. The shadows were picked out with the tip of a medium brush, this time using cadmium red with a touch of ultramarine.

As the windows were reflecting the colours around them, the following technique was used. First, a mixture of ultramarine, cobalt blue and a touch of burnt umber was mixed and applied evenly using a medium brush. Then, while the paint was still wet, a drop or two of clear water was dripped into the centre of the panes, pushing the paint outwards, creating a reflective shape. Also, a little cadmium red was applied to the wet paint at the top of the pane and allowed to bleed downwards, enhancing the reflection from the awning. A little raw sienna was dropped onto the wet paint at the bottom of the pane to act as the reflection from the sign, and this was also allowed to bleed. This technique needs to be done quickly, using a small brush.

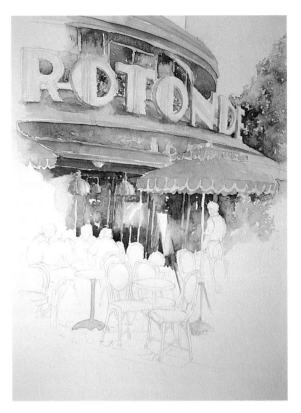

4 The windows and glass doors were painted using a medium brush and the same technique as the windows at the top of the café, only cobalt blue was dropped into the centre and washed across the menus and signs, giving the appearance that they were behind the glass.

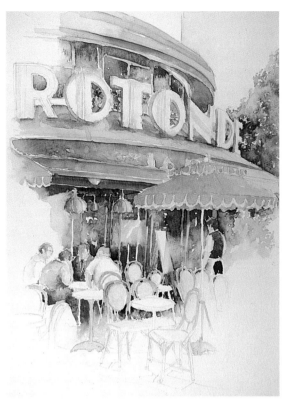

5 Figures were painted with flesh tones of watery raw sienna and a touch of cadmium red, using a small brush. When the paint had dried, shadows were created with a thin cobalt blue wash around arms and faces.

Having completed the top section of the café, and achieved some light and shade, the next stage was to establish a backdrop against which the figures could clearly be seen, using the same technique that was used to make the sign stand out on the opposite page. A very dark set of tones were applied to the doors and windows, carefully working around the people sitting at the café tables. The same principles were applied as when painting the windows at the top of the building, only some shapes had to be more clearly defined, and additional colours introduced.

The darker sections at the top of the glass panels were painted using a small brush, this time to record some more finely detailed shapes. A very strong yet watery mixture of ultramarine and burnt umber was applied to

the top of the glass and pulled downwards, working around the shapes of menus, lamps, and so on. A drop of watery cobalt blue was then dropped into the middle and allowed to bleed across some of the white shapes. Then, before any of this had time to dry, a little cadmium red and a touch of cadmium yellow were dropped on to act as the reflections of the interior lights and the blinds. With some speed, the initial dark paint was applied around the figures, in the knowledge that it would blend with the watery mix in the middle of the pane, but not bleed right up to the top, obscuring the subtle tones there.

The figures, as negative shapes, needed just a touch of skin colour (see page 110), and a light wash of cobalt blue applied selectively across the faces, arms and backs.

119

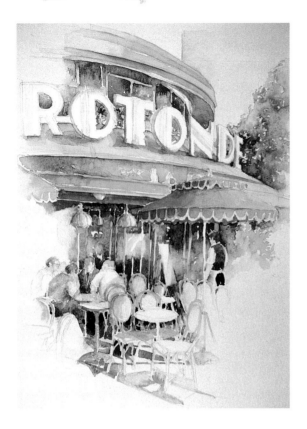

6 Shadows on the ground were picked out with a small brush and a mixture of cobalt blue, ultramarine and burnt umber. Only the main shadows were included to prevent overcrowding the foreground.

Open-fronted cafés have a wealth of visual interest – the dark interior of the building with its bar, the customers and waiters, chairs, tables and umbrellas, and details such as lights, menus and posters. It is not realistic to consider recording everything, so be selective

The final stage was probably the most important as it involved anchoring the figures to the ground by recording the shadows cast by the tables and chairs at which they were seated, making them part of the forecourt and, consequently, part of the café building.

The complexity of the criss-cross of shadows cast by the jumble of chair and table legs could not have been recorded fully without distracting attention away from the figures and the shapes of the building itself, so I decided to suggest only some of them.

Using a small brush and a mixture of ultramarine, cobalt blue and burnt umber, I picked out and carefully painted the main lines of the shadows that I could see. These were painted using precise, single brush-strokes, and allowed to dry with hard edges, suggesting the strong light of the day. The depth of tone of some of these shadows also made it considerably easier to see some of the table and chair legs as these were thrust forward by the power of the dark tones, and appeared as negative shapes.

The areas where little light reaches (underneath the tables and chairs and in the background) were painted using a very strong deep mixture of ultramarine and burnt umber. The strength of this tone allowed the white shirts of the customers to work for themselves as negative shapes

The finishing touches involved applying a cobalt blue wash across the chairs and tables, and securing the umbrella and table stands to the ground through the use of shadow and colour. The deep reds of the stands were established, and the shadows on the left-hand sides were completed by adding a touch of ultramarine when the red paint was fully dried. This had the effect of enhancing the appearance of strong shadows on a glorious spring morning.

LA ROTONDE CAFÉ

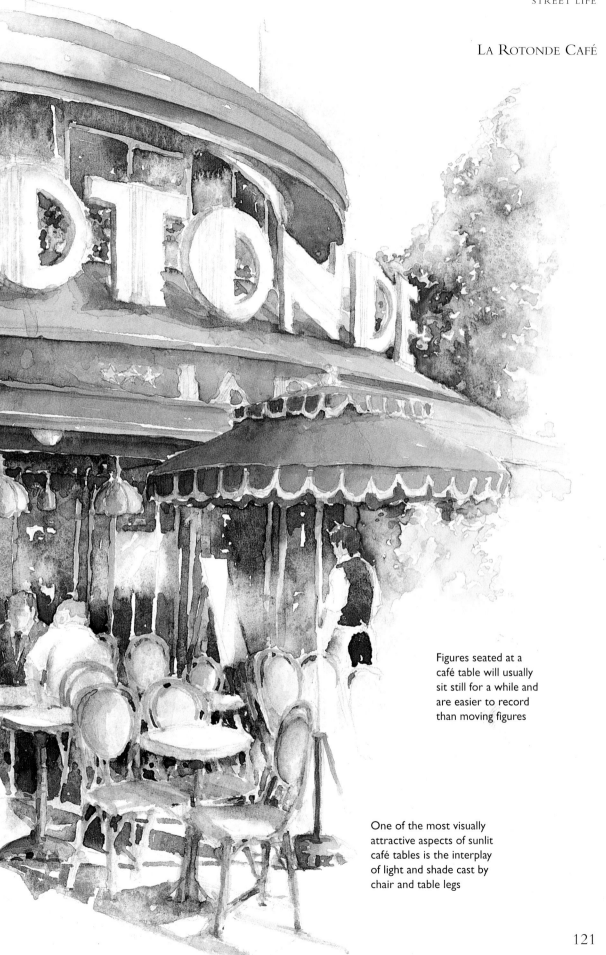

Figures seated at a café table will usually sit still for a while and are easier to record than moving figures

One of the most visually attractive aspects of sunlit café tables is the interplay of light and shade cast by chair and table legs

Final Thoughts

WHILE WATERCOLOUR PAINTS HAVE MANY FINE QUALITIES, THEIR GREATEST POTENTIAL LIES IN THE HANDS OF THEIR EXPONENTS. SO, OVER TO YOU NOW!

This painting makes a fitting conclusion to this book, in which I hope you have discovered the wonder of the built environment. Here, a windmill – a traditional rural structure – is surrounded by the trappings of a twentieth-century town – street signs prohibiting traffic, cars and shop awnings: the old and the new found existing harmoniously side-by-side.

The paintings in the book will give you some ideas about subjects that I urge you to seek out and enjoy. The techniques, as in any art or craft, will require practice. (Instant success, if it ever happens, is rarely satisfying.) But they are accessible and, with a little time and courage, can be mastered. From that point on, you will be able to take the techniques that you personally find enjoyable and will, eventually, be able to adapt them to suit your requirements, ultimately making them your own.

So, where exactly do you go from here? Again, the answer is in your hands, and will depend totally upon your aims and wishes. If this book has encouraged you to venture out onto the streets with a sketchbook and a tin of watercolours, then I am delighted. If it has simply introduced you to an alternative way of painting, or helped you to understand how to be selective in conveying the textures and patterns of buildings by employing the technique of suggestion, then I am equally pleased. To whatever use you have put this book, my greatest wish is that it will enhance your success and the subsequent pleasure that you gain from your painting.

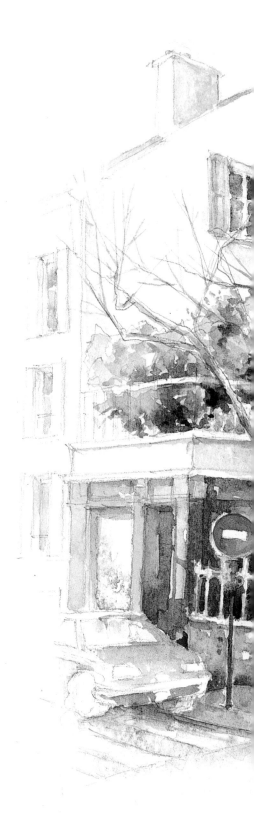

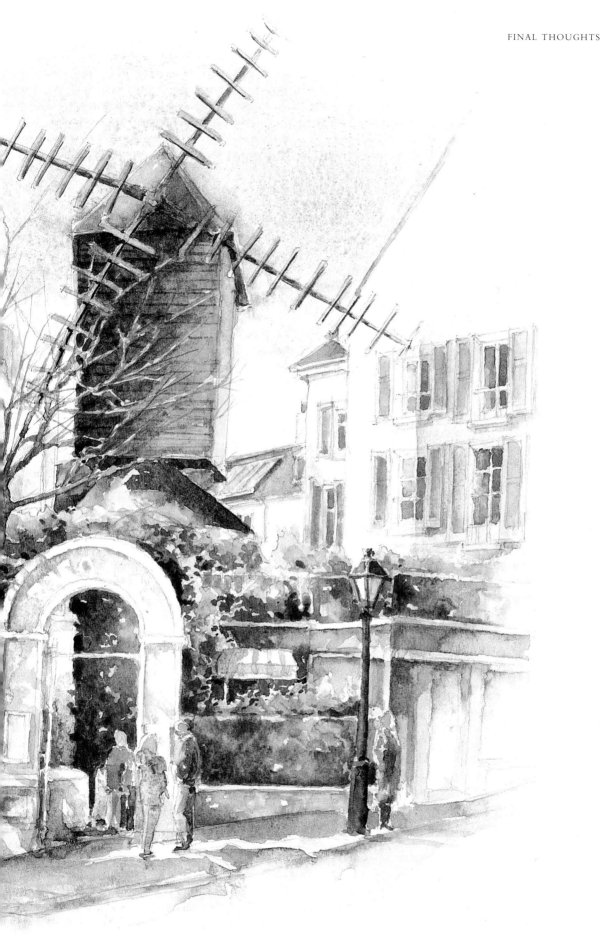

CITY WINDMILL

Glossary

ARCHITECTURAL TERMS

ARCH A curved structure often found as an opening, or as a support for a bridge, roof or floor. Also used as decoration.

ARCHITRAVE The main beam across the tops of columns. Also used to refer to the moulded frame around a doorway, window or arch.

ASYMMETRY The lack of symmetry.

AWNING A sheet of canvas or similar material stretched on a frame and used to shade a shop window or door from the sun or rain.

CLOISTER A covered walk, often with a wall on one side and a colonnade open to a quadrangle on the other.

COLUMN An upright cylindrical pillar often slightly tapering, and often supporting a beam or arch.

CORRUGATED IRON Iron sheet formed into alternate ridges and grooves for strengthening.

COURTYARD An area enclosed by walls or buildings, often opening off a street.

CRYPT An underground room or vault, especially one beneath a church.

EAVES The underside of a projecting roof.

GUTTERING The shallow trough below the eaves of a house to carry off rainwater.

PILLAR A usually slender vertical structure of wood, metal or stone used as a support for a roof, or as an ornament.

PLASTER Soft, pliable mixture of lime, sand and water, used as a covering for walls and ceilings, forming a smooth, hard surface when dried.

PORCH The covered entrance to a building.

QUADRANGLE A four-sided court, especially enclosed by buildings.

STUCCO Cement or plaster coating for exterior walls; also used for decorative mouldings.

SYMMETRY The proportion of the parts of a building, showing balance and harmony.

TERRACE A row of attached houses built as one unit.

VAULT An arched roof. This may be a continuous arch, or a set of arches whose joints radiate from a central point or line.

WEATHERBOARDING Overlapping horizontal planks or boards of wood covering timber-framed walls.

ART TERMS

BACKGROUND The distant area behind the main subject of a composition, extending to the horizon.

BASE COAT/COLOUR The first application of watercolour paint onto the blank paper. Also known as the undercoat or underwash.

BLEEDS The running or diffusion of colour that occurs when wet paint is moved across the surface of paper, usually by another application of water.

BLENDING Combining, with an element of control, two or more colours on the paper to create a clearly defined area of paint.

BLOTTING The removal of any surface water/paint with an absorbent material to create texture or to soften an edge.

COLOUR TEMPERATURE The impression of heat or cold that any given colour imparts.

COMPOSITION A term used by artists to describe the way in which they arrange the subject within the picture area.

DRIPPING/DROPPING A technique that involves allowing small amounts of water to drip from the tip of a brush, usually onto wet or damp paper.

FLATTEN To detract from the three-dimensional appearance of any given area.

FOREGROUND The area in front of your painting/sketching position; also the area in the front of your painting.

FORM An appearance of three dimensions created while painting, making an object look as if it has mass.

GLAZE Thin wash layer.

MIDDLE GROUND The area between the foreground and the background.

NEGATIVE SHAPES Shapes that appear either white, or particularly light, against an adjacent colour of a darker tone.

PERSPECTIVE A system developed for translating a three-dimensional scene onto a flat sheet of paper.

Linear A means of conveying the effect of distance and scale by the use of converging lines.

Tonal The use of tone to convey a sense of distance by using lighter tones in the background and stronger tones in the foreground.

POSITIVE SHAPES Shapes that stand out by themselves, usually dark shapes placed in front of a light background.

PULLING PAINT A particularly positive brushstroke in which water or paint is brushed away from a specific point.

RUNS These occur when wet paint is moved across the surface of paper, usually by another application of water.

TINT A very pale, barely discernible colour wash.

TONE The lightening or darkening of a colour.

TRANSLUCENCY The main quality of watercolour paints - clear, but only partially transparent.

UNDERCOAT/UNDERWASH See base coat.

WASH The application of either paint or water in fluent strokes.

WET-INTO-WET A technique that involves applying wet paint to a wet or damp sheet of paper, causing the paint to bleed outwards.

Acknowledgements

The inspiration for this book has come from countless generations of architects, stone masons, carvers, and builders – unnamed people, long since consigned to the history books.

There are, however, those chosen names who must be recorded in acknowledgement of the assistance that they have given me in the actual production of this book – primarily my wife, Debbie, who has worked tirelessly in support of my writing, checking each and every word for its accuracy and deconstructing sentences with vigour!

My sister, Gina, also warrants recognition for her help in locating areas of visual interest and gathering references.

Finally, I wish to acknowledge the longlasting support of an old friend, Margaret Cameron. The gift of her late husband's 'Banister Fletcher' has become as valuable as her advice to me, as a young student, about the realities of surviving in the professional art world.

Index